EMILY CARR

COLLECTED

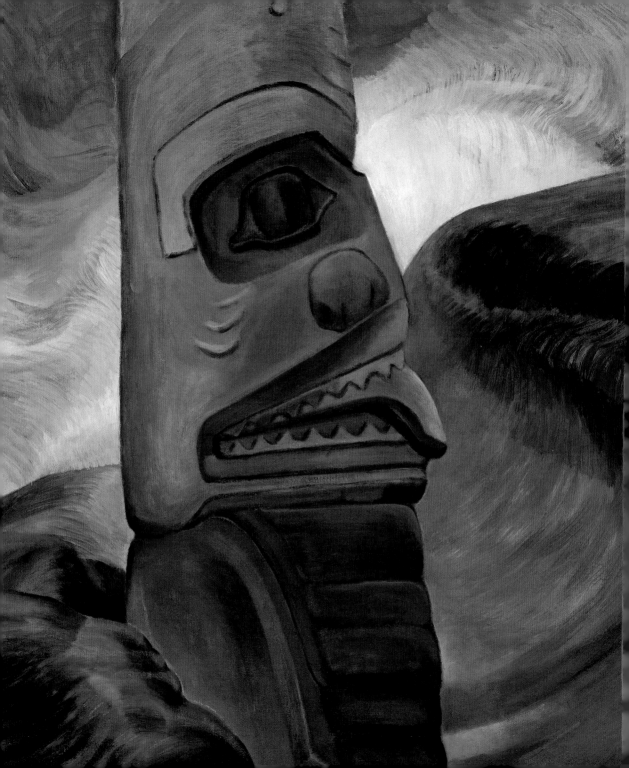

EMILY CARR

COLLECTED

INTRODUCTION BY **IAN M. THOM**

Douglas & McIntyre

in association with the Vancouver Art Gallery

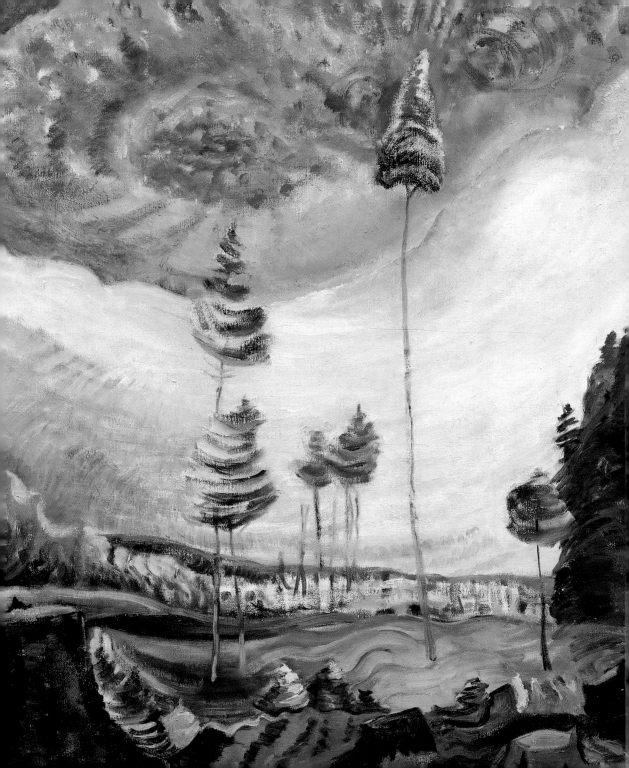

"A Lone Old Tree"
The Art and Life of Emily Carr

IAN M. THOM

WHEN IN the spring of 1933 Emily Carr described herself as "a lone old tree,"[1] she was feeling sorry for herself and could never have imagined that she would become one of Canada's most celebrated artists and writers. Like all artists, she was at times wracked with self-doubt—unsure of her direction, the quality of her work and the meaning of her life.

Little about Carr's birth and upbringing suggests that she was destined to make art central to her life. Born the youngest daughter of a well-to-do Victoria merchant, Richard Carr, she shared her mother's name, Emily, but was generally known to her family as Millie. She reported drawing as a young child and receiving art lessons as an adolescent, but it was not until she went to San Francisco in 1890 that her formal studies began. Carr spent three years in San Francisco, but, unfortunately, little work remains that can be securely dated to that period of her life.

On her return to British Columbia, she began to work as a teacher of children's art classes and to exhibit her work. Early drawings, such as

Snowdrops, reveal Carr as a competent but not particularly skilled draughtsman. The most important event of her early career was perhaps her decision to visit Ucluelet, on the west coast of Vancouver Island; the drawings that she produced as a result of that trip (now in the Royal British Columbia Museum) are her first images of First Nations peoples and their way of life.

The following year, 1899, Carr travelled to England to continue her schooling. She enrolled at the Westminster School of Art in London but found the city overwhelming and soon sought out classes in Cornwall. There, at the St. Ives art colony, she worked with the painters Algernon Talmage and Julius Olsson and later spent time at John Whiteley's school in Bushey. Carr reports on this period in her book *Growing Pains*, and it was apparently a time of considerable strain and difficulty for her. By 1902, with her health in decline, Carr was forced to enter a sanatorium in Suffolk, where she spent some eighteen months.

The artist who returned to British Columbia from England in late 1904 was older but not substantially better trained. The known works from that period, such as *Chrysanthemums*, are conventional and rarely experimental in colour or form. Indeed, Carr felt defeated by the whole English experience and didn't look forward to a bright future. She was, however, determined to make her way as an artist and, in 1906, moved to Vancouver to take up a post as a teacher of art at the Vancouver Studio Club. She exhibited her work to modest success, and the watercolours from the period are increasingly skilled.

A 1907 trip to Alaska with her sister Alice alerted Carr to the possibility of making the totemic work of the First Nations her subject matter. In

the three years following, Carr made return trips to Alert Bay and other First Nations communities but felt that she needed to expand her training. In the fall of 1910, she travelled to England and then to Paris in search of "modern art," though it is unlikely that Carr herself knew what that meant. Unable to speak French, she did not do well in the art schools of Paris and was soon drawn to the classes of expatriate English-speaking artists.

Carr worked with the Scotsman John Duncan Fergusson and spent time in the countryside with Harry Phelan Gibb and later in Brittany with Frances Hodgkins. Each of these artists, but particularly Gibb, was important to Carr's development. They all emphasized *plein-air* painting, or painting outside on location, which she had done in both San Francisco and England, but she was also encouraged to use non-naturalistic colours influenced by the example of the Fauve painters, Henri Matisse, André Derain and others. This brought a new freshness and vigour to Carr's handling of paint, which is clearly seen in works such as *French Landscape* and *Women of Brittany*. Carr was in France for less than a year, but it was a transformational experience, and upon her return to Canada, she was equipped with the artistic tools to begin her mature work.

In the summer of 1912, when she was forty-one years old, Carr embarked on an ambitious sketching trip that took her to the Skeena and Nass Rivers, Alert Bay and Haida Gwaii. In the field, she produced watercolours and small oils, and in the fall and winter of 1912–13 in her Vancouver studio, she produced canvases based on these field studies. The primary goal of this large body of work was to document the villages and totems of First Nations people, which Carr, like most Euro-Canadians of her generation,

believed were destined to disappear. She made a particular effort to record house fronts and poles accurately, using the colour sense and paint-handling skills she had gained in France. In the spring of 1913, she held a major exhibition of these works in Vancouver and hoped the bulk of them might be purchased by the provincial government. This did not happen, and the economic slump that hit British Columbia in the period just before the First World War meant that Carr was unable to sustain a studio or make a living in Vancouver. She returned to Victoria in 1913.

Between 1913 and 1927, Carr did little painting because she felt that there was no support for her art. There are experiments treating the British Columbia landscape with the brilliant Fauvist colours, but these are infrequent, and the *Untitled (Self-Portrait)*, which she painted during this period, gives us a strong hint of the misgivings she had about her painting. Gone is the confident, even bossy, individual we saw in the earlier *Self-Portrait with Friends;* here we don't even see Carr's face, and the painting on the canvas is inchoate. Carr spent most of her time raising dogs, making pottery using First Nations motifs, weaving rag rugs, growing soft fruit, running a boarding house (which she details in her book *The House of All Sorts*)—all in pursuit of making a living.

In 1927, Carr was invited to participate in an exhibition being organized for the National Museum in Ottawa by ethnologist Marius Barbeau. Called *West Coast Art: Native and Modern*, the exhibition, to which Carr contributed more than twenty of her 1912 paintings, as well as pottery and rag rugs with First Nations motifs, marked a turning point in her career. Not only was her work seen by a wide audience outside British Columbia

(the exhibition also went to Toronto and Montreal), but Carr also travelled with the exhibition and met other leading Canadian artists, most notably members of the Group of Seven, A.Y. Jackson, Arthur Lismer and Lawren Harris. She and her work were embraced by these artists. In her journals, *Hundreds and Thousands*, Carr records her first impressions of Harris's work: "Something has spoken to the very soul of me, wonderful, mighty, not of this world."[2]

The Group of Seven's approach to the Canadian landscape resonated with Carr and helped her to focus her own spiritual and visual journey. Immediately upon her return to British Columbia, Carr began painting again, and works such as *Skidegate* and *The Crying Totem* reflect a new confidence in her subject matter and a new, more forceful treatment of the totemic subject within a landscape. She made plans to return to northern British Columbia, to the Nass and Skeena River villages (Hazelton, Kitwancool and others), and in the summer she visited Haida Gwaii, including Masset and Skidegate. At fifty-six years old, she was embarking on the most productive and rich period of her career.

Carr had begun a correspondence with Lawren Harris that allowed her, for the first time in her life, to discuss matters of art and the spirit with a fellow traveller who both valued and respected her. Carr's enthusiasm is manifest in the enormous group of watercolours she produced that summer and in the oil paintings and drawings that poured out in the next few years. She also expanded her artistic horizons in a workshop with the young Seattle-based Modernist Mark Tobey, who encouraged her to revisit the basics of her art, concentrating on drawing and form.

In the wake of her study with Tobey, during the last two years of the 1920s and the early '30s, Carr produced an exceptional group of charcoal drawings that are among the most challenging and interesting works of her career. Some were executed on the spot, but others, such as *Agidal, Nass River*, were done in the studio using rough field notes and demonstrate great formal control.

Similarly, the paintings of the period are remarkable achievements, whether small and dramatic like *The Raven* or larger as in *Old Time Coast Village*—both of which resonate with a depth of feeling and a powerful pictorial force. Carr reviewed all of her earlier First Nations studies and was able to use a wonderful 1912 watercolour, *Cumshewa* (now in the National Gallery of Canada), as the basis for a majestic reworking of the subject, which she entitled *Big Raven*. In the latter, the totem stands proudly in a swirling sea of undergrowth, and the power and spirit of the carving are echoed in the shafts of light from the sky.

The 1930s also saw Carr adopt new painting techniques. Increasingly, she felt that watercolours were not adequate as a sketching material and began to use oil on paper. By thinning her paint with gasoline and using relatively inexpensive paper as a support, she was able to achieve a new richness in her sketches, and the lightweight materials and quick-drying medium allowed her to continue to work in the open. To begin with, Carr used these oils on paper as the basis for larger canvases, such as *Tree Study* and *Tree Trunk*. She soon realized, however, that these works on paper were paintings in their own right, and most of the oils on paper do not have corresponding canvases.

During this same period, Carr turned her attention to the landscape: the forests and parks around Victoria and, in 1933, the area around Pemberton, in the Coast Mountains. In this new subject matter—the mountainous terrain near Pemberton and the sea and sky near Victoria—Carr felt a deep spiritual connection to the landscape of the province, and it was in the forests that she felt the living presence of God.

Although she was not a conventionally religious woman, Carr, after a brief flirtation with the ideas of theosophy, felt that her art should express the ecstasy and wonder she felt in the natural world and that this was, in effect, a form of worship. As she wrote in her journals, "Draw deeply from the good nourishment of the earth but rise into the glory of the light and air and sunshine."[3] In 1933, she purchased a caravan, The Elephant, which she had towed to locations around Victoria to allow her to explore various landscapes.

In 1937, Carr suffered her first heart attack, and her activities as a painter were drastically curtailed. No longer able to sketch from her beloved Elephant, she was forced to rent summer houses and cabins, and increasingly, Carr turned her attention to writing, which she had explored since the early '30s. In late 1937, she sent a group of "Indian stories" to Dr. Garnet Sedgewick of the University of British Columbia for criticism. Some of these stories, which became her first book, *Klee Wyck*, were later read by Sedgewick on CBC Radio in 1940. In addition to writing, Carr produced several oils on paper in 1938 and 1939. Works such as *Deep Woods* and *Above the Trees*, which are among the finest of her career, display a complete mastery of her technical means and convey the vital energy of the natural

world in a way that is absolutely convincing more than seventy years later. That year, however, she suffered a second heart attack, and her movements were further curtailed. She was polishing the stories that would become *Klee Wyck*, which was published in 1941 to great acclaim, winning the Governor General's Award for Literature.

The last few years of Carr's life were marked by growing recognition as a writer and artist but increasingly poor health: she suffered a stroke in 1940 and another in 1944. This meant considerable time in hospital and more attention to writing than painting when she was fit. (Carr eventually wrote seven major works, including *The Book of Small*, which was published during her lifetime, but most of the books appeared posthumously.) However, perhaps because of the renewed interest in her "Indian" work with *Klee Wyck,* she revisited First Nations themes in a small group of works in 1941–42. The most important of these are two wonderful paintings, *A Skidegate Pole* and *A Skidegate Beaver Pole*. Both are based on small sketches done in the Haida village of Skidegate in 1912, but the transformation in the images is remarkable. Where the earlier studies, clearly influenced by Carr's desire to accurately record the totemic carvings, seem somewhat tentative, with little connection between the landscape and the poles, in the later canvases, the poles and the landscape are united in a single vibrant whole.

Carr took her last painting trip in August of 1942, when she worked in Mount Douglas Park, near Victoria. The oils on paper and canvases that resulted from this trip are, in many ways, a culmination of her career. Works such as *Cedar Sanctuary* and *Cedar* are a perfect union of subject

and means. They reflect the profound beauty of nature and Carr's almost uncanny ability to capture both the form and the essence of the forest. The "lone old tree" is one with the world.

In 1941–42, with the assistance and advice of Lawren Harris, Carr had set aside a group of forty-five of her canvases in trust for the citizens of British Columbia. This collection became the core of the Emily Carr Trust, now held at the Vancouver Art Gallery. (This collection was augmented by another group of paintings when the Emily Carr Trust was formally dissolved in 1966.) In 1944, she had the only successful commercial exhibition of her career, at the Dominion Gallery in Montreal. Although Carr was gratified by the success, she was too ill to really appreciate it.

Carr passed away in Victoria on March 2, 1945, at the age of seventy-four. A memorial exhibition was organized in October of that year at the Toronto Art Gallery (now the Art Gallery of Ontario), which had kept much of her work for safekeeping during the war. Since her death, Carr's fame has continued to grow steadily; she is now admired as one of the most important Canadian artists of the twentieth century and widely recognized as British Columbia's greatest painter. Her profound love of the landscape of the province and her deep, if not always fully comprehending, exploration of First Nations totemic art continue to speak to audiences here and around the world.

1. Carr, Emily, *Hundreds and Thousands: The Journals of Emily Carr* (Vancouver: Douglas & McIntyre, 2006), 156.

2. Carr, *Hundreds and Thousands*, 25.

3. Carr, *Hundreds and Thousands*, 57.

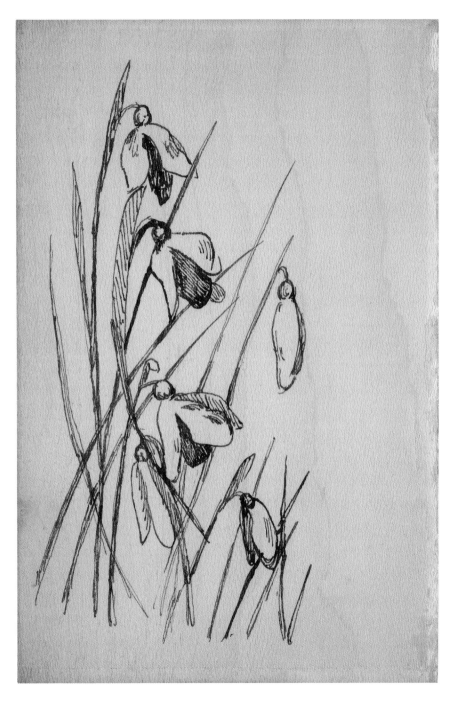

Snowdrops c. 1894

Ross Bay Road. Victoria

Bend of the Road Plumpers Pass.

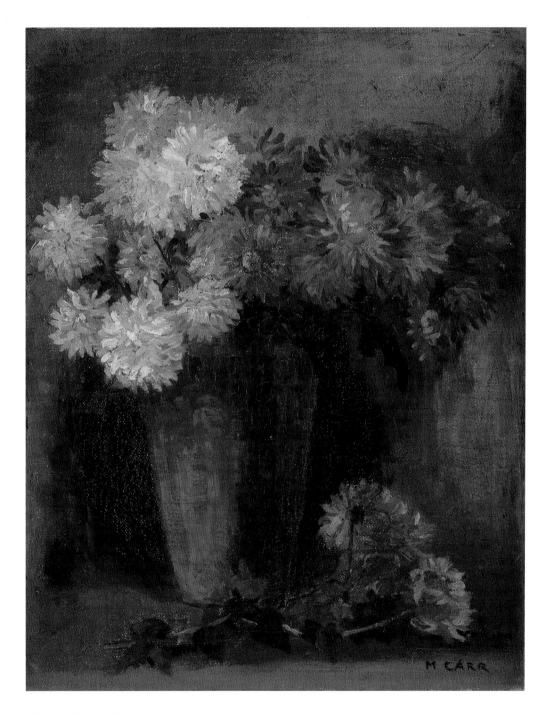

Chrysanthemums c. 1900

Indian Reserve, North Vancouver c. 1905 19

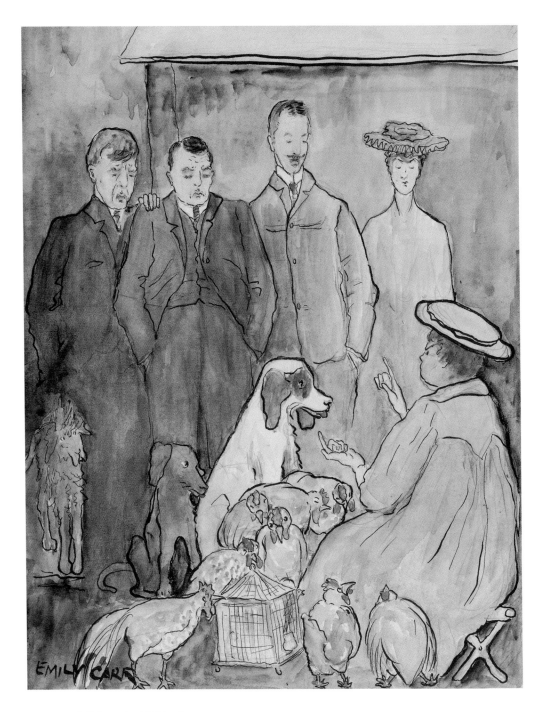

Self-Portrait with Friends C. 1907

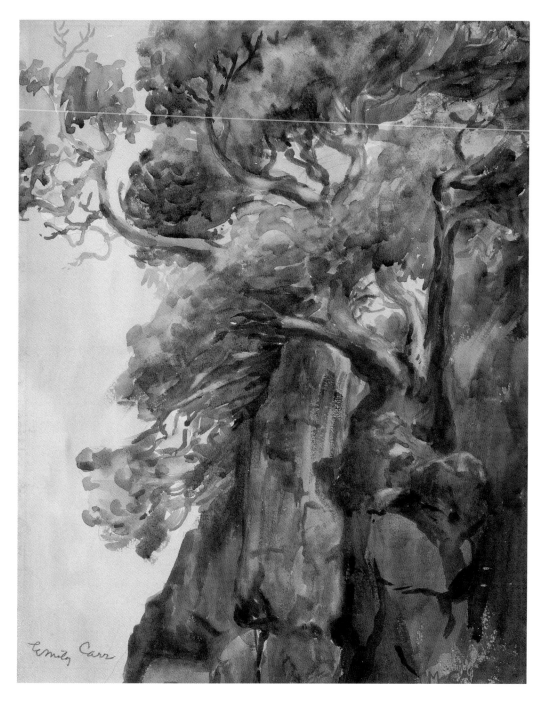

Arbutus Tree 1907–08 21

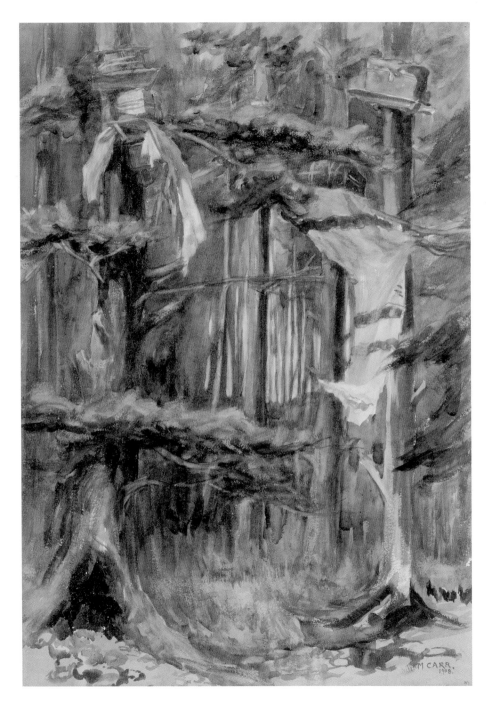

Alert Bay, Mortuary Boxes 1908

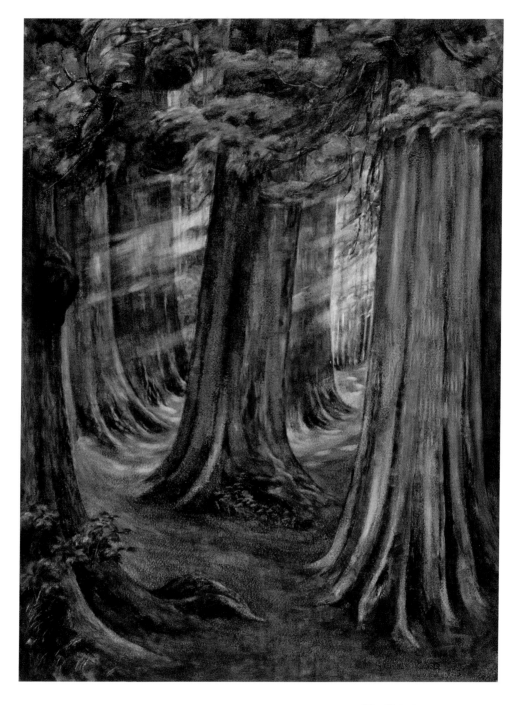

Wood Interior 1909 23

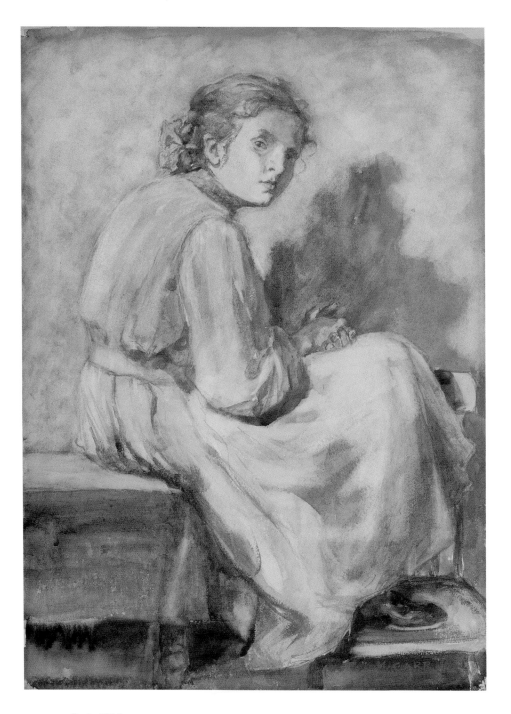

Seated Girl 1909

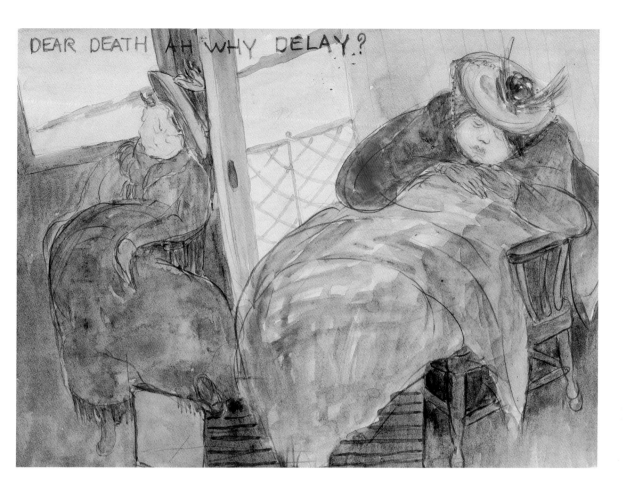

Dear Death, Ah Why Delay? C. 1910 25

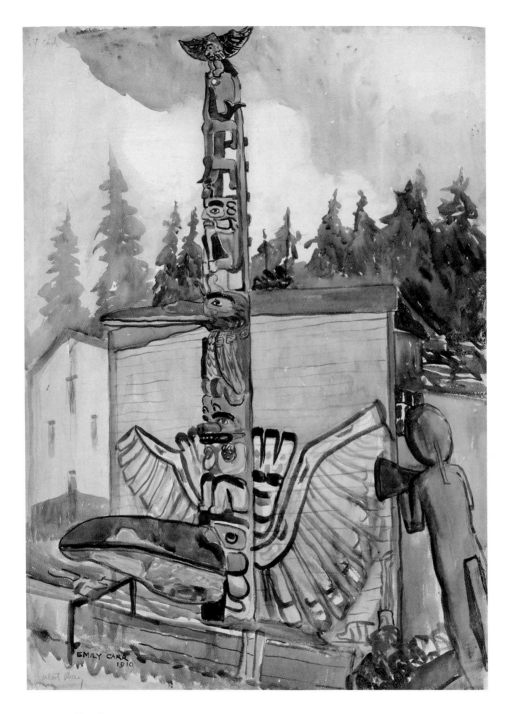

Alert Bay 1910

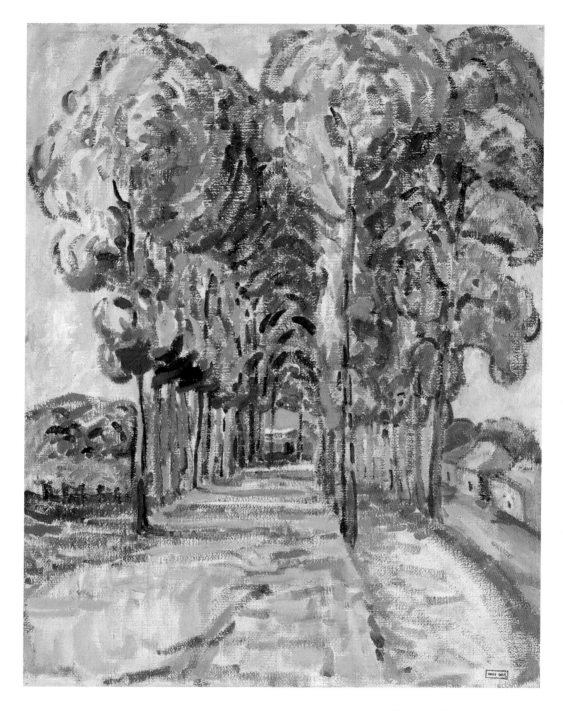

French Landscape 1911

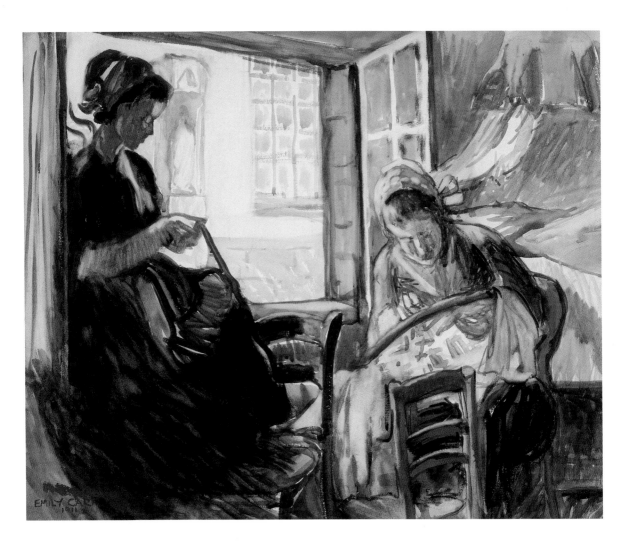

Women of Brittany 1911

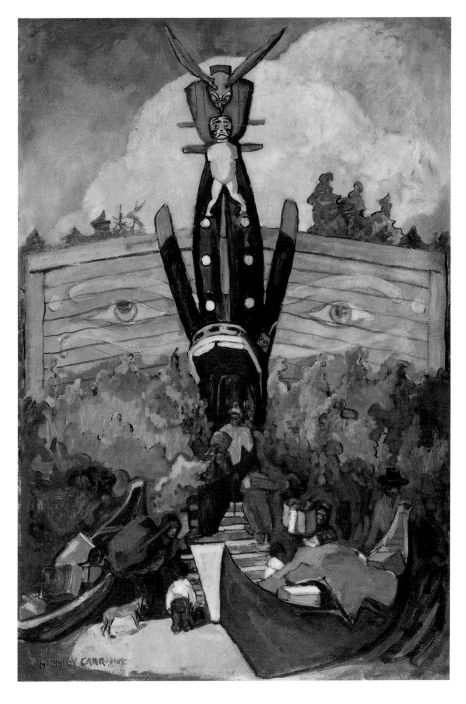

Return from Fishing, Guydons 1912

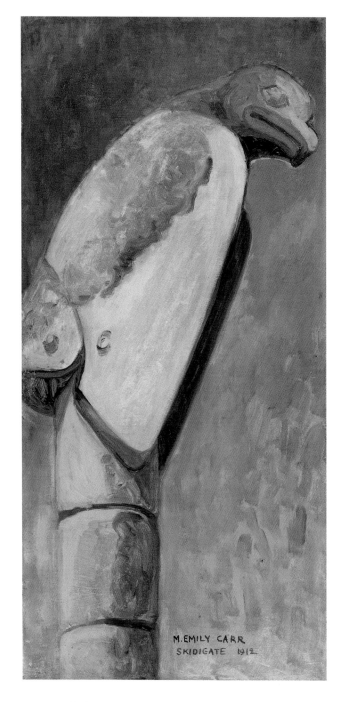

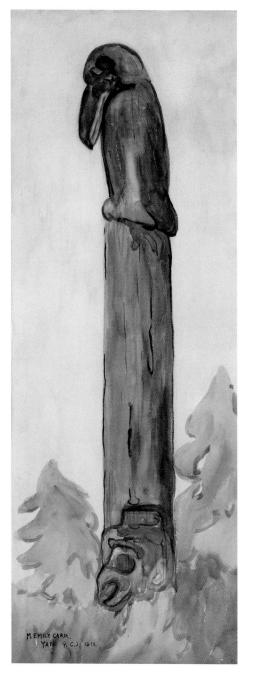

Skidegate 1912

Yan, Q.C.I. 1912

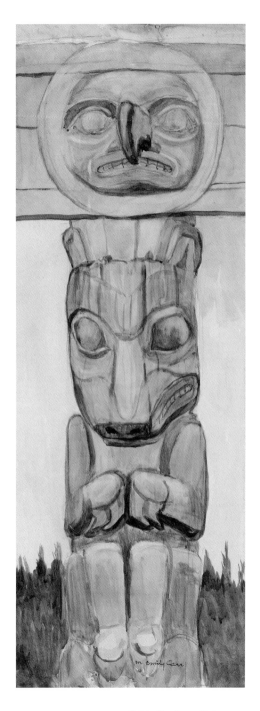

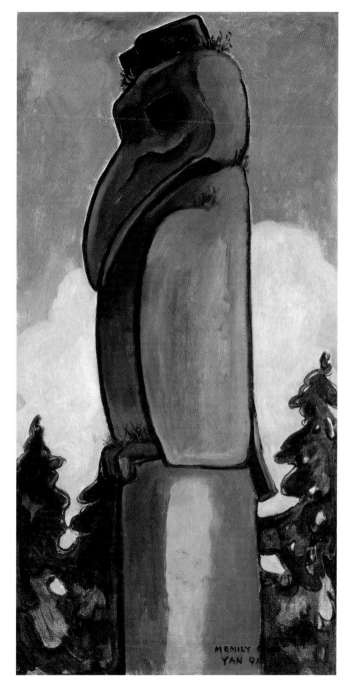

Haida Mortuary Pole 1912

Indian Raven, Yan 1912

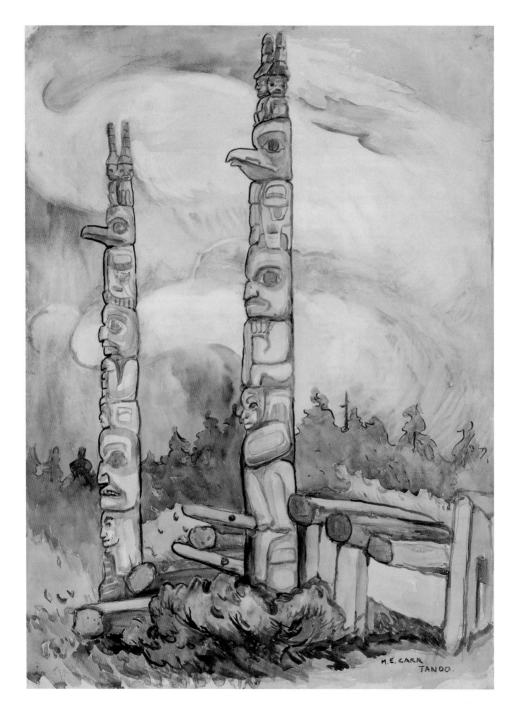

Tanoo 1912

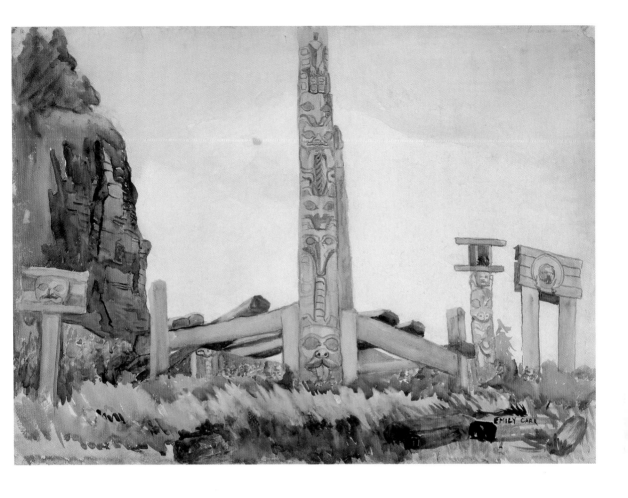

EMILY CARR

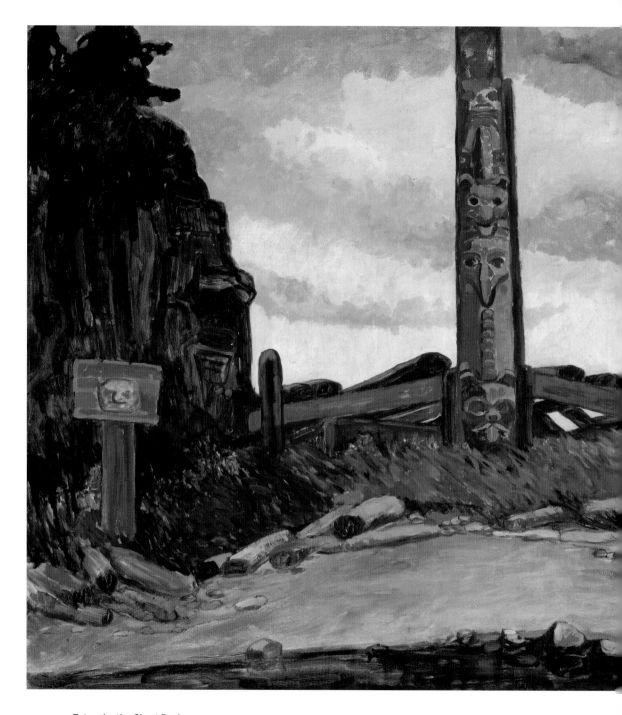

Totem by the Ghost Rock 1912

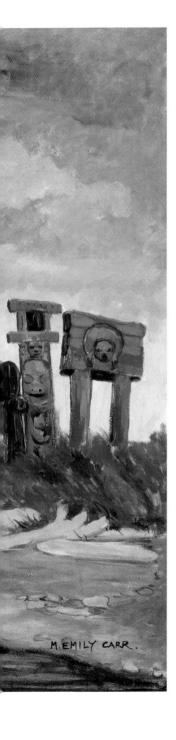

M. EMILY CARR.

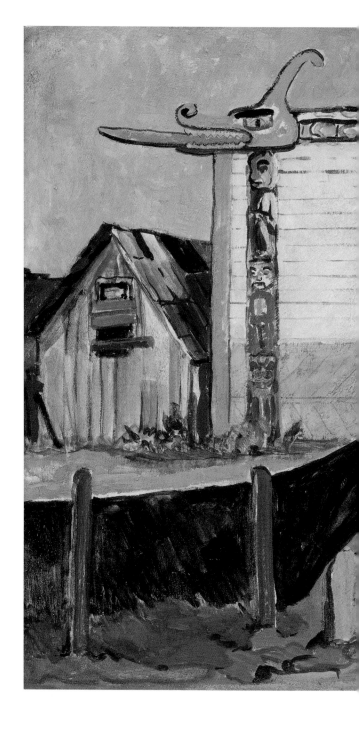

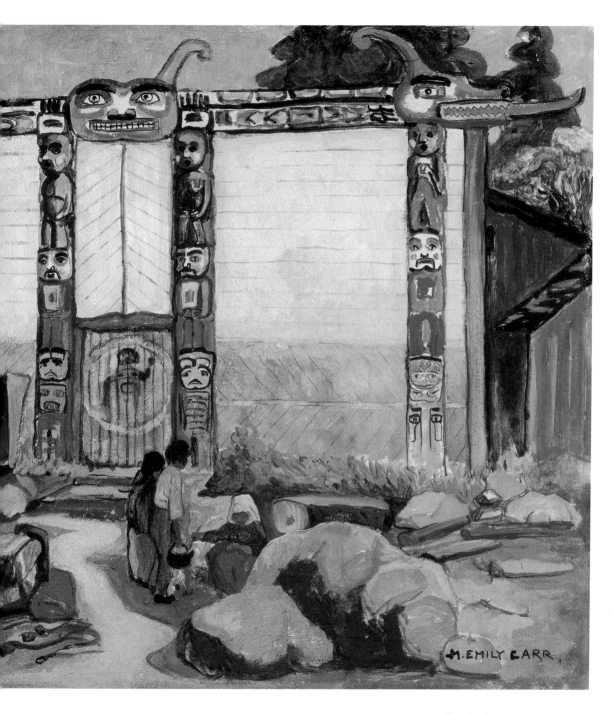

Kwatkiutl House 1912

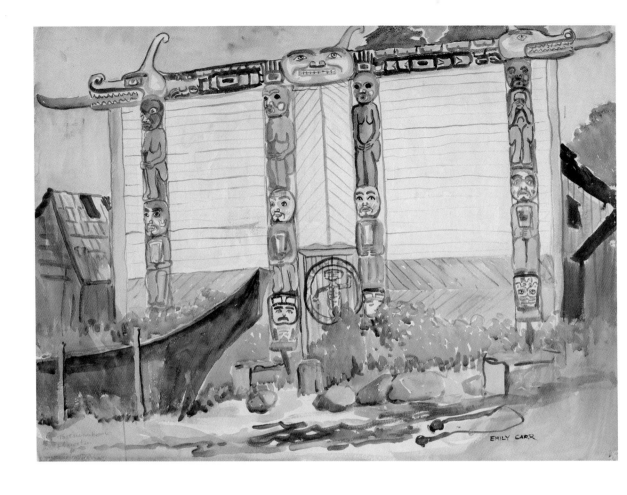

Tsatsisnukomi, Tribe Klawatsis 1912

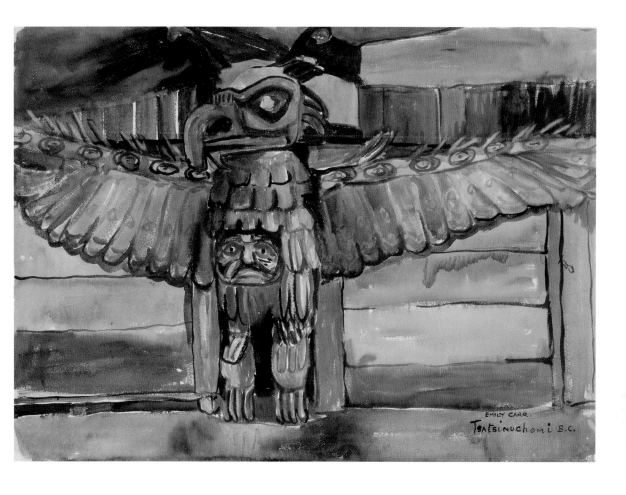

Tsatsinukomi, B.C. 1912

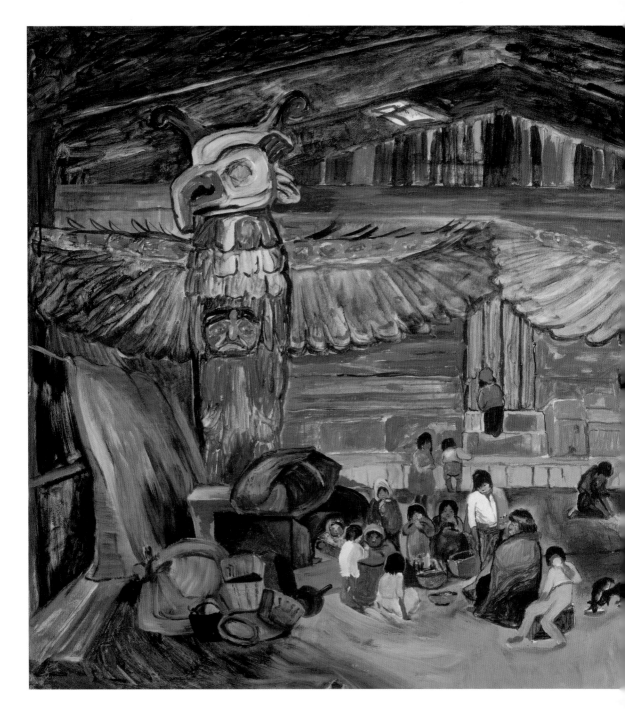

Indian House Interior with Totems 1912–13

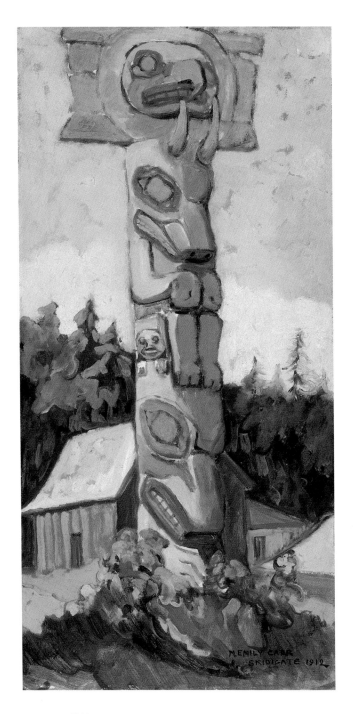

Skidegate 1912

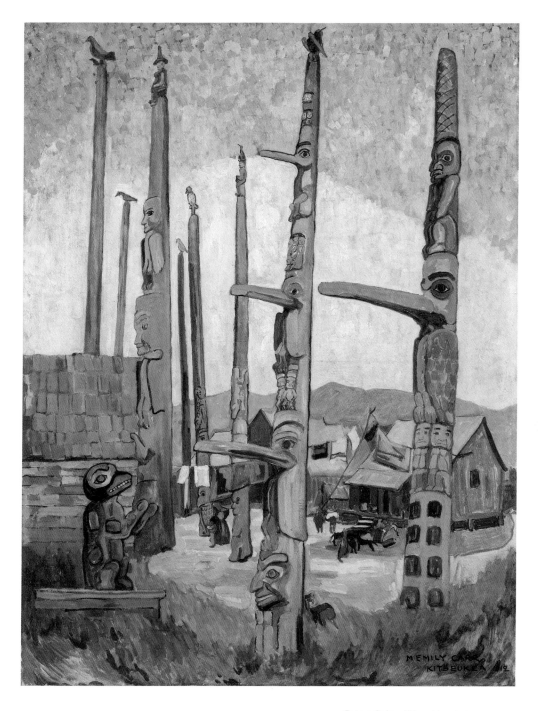

Totem Poles, Kitseukla 1912 43

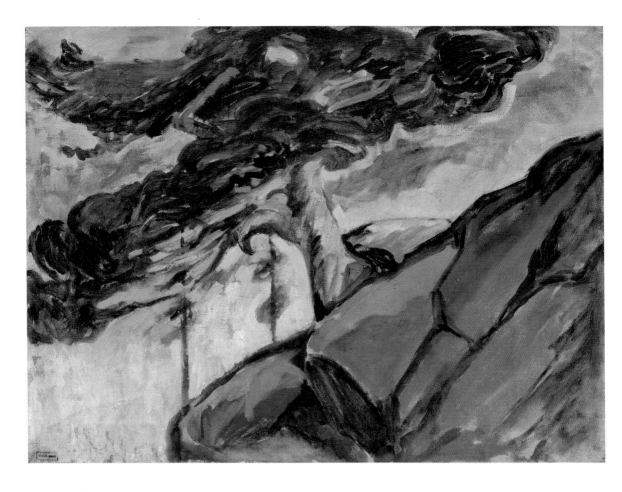

44 **Untitled (Tree on a Rocky Profile)** 1922–25

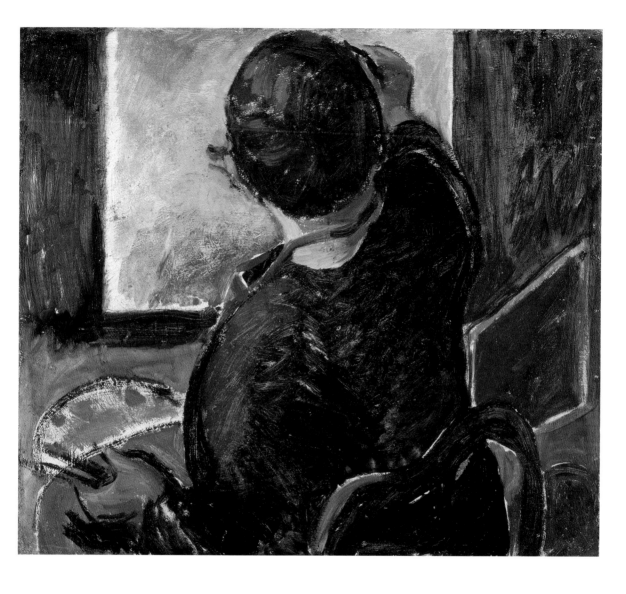

Untitled (Self-Portrait) 1924 45

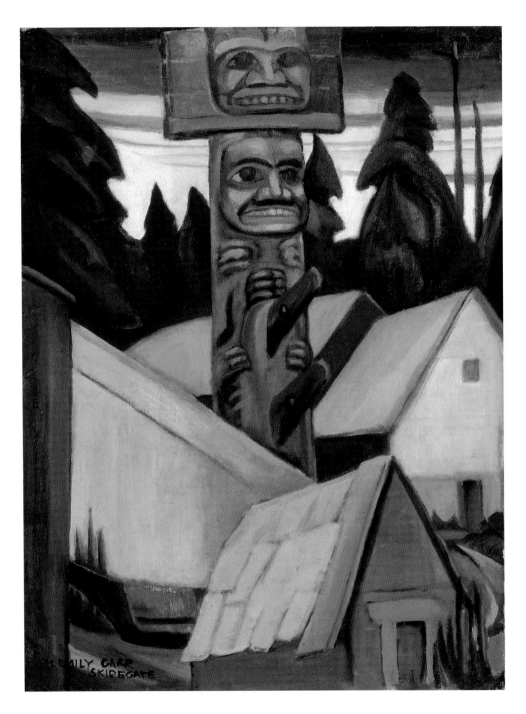

Skidegate 1928

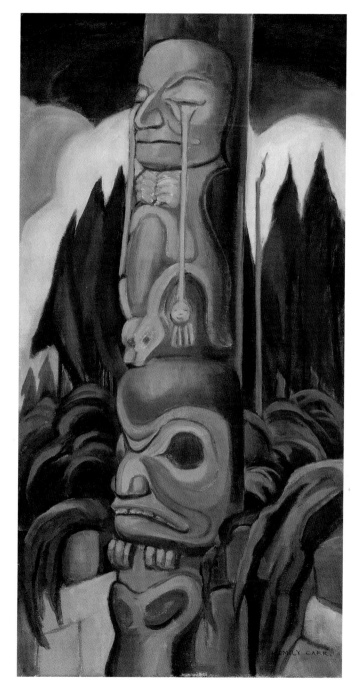

The Crying Totem 1928

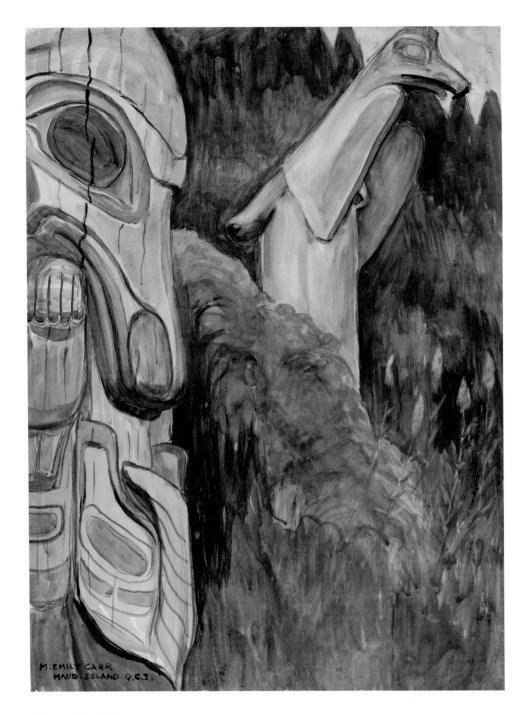

M. EMILY CARR
MAUD ISLAND Q.C.I.

Maud Island, Q.C.I. 1928

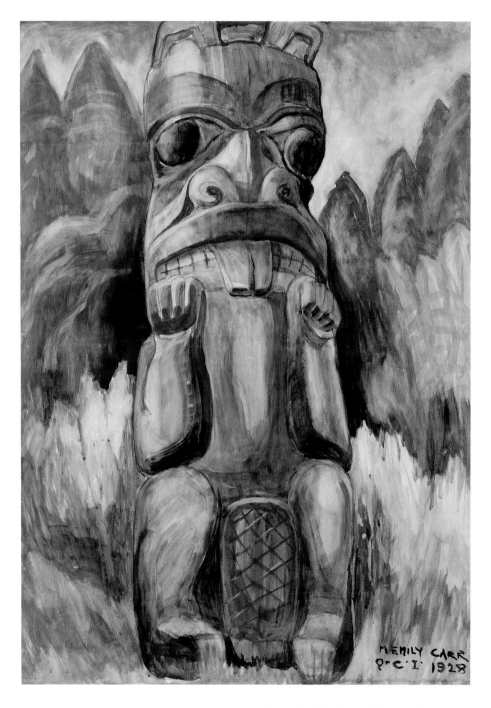

Queen Charlotte Islands Totem 1928

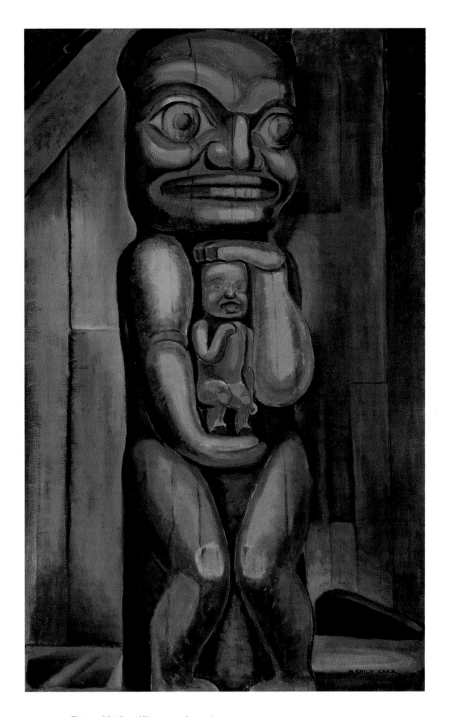

Totem Mother, Kitwancool 1928

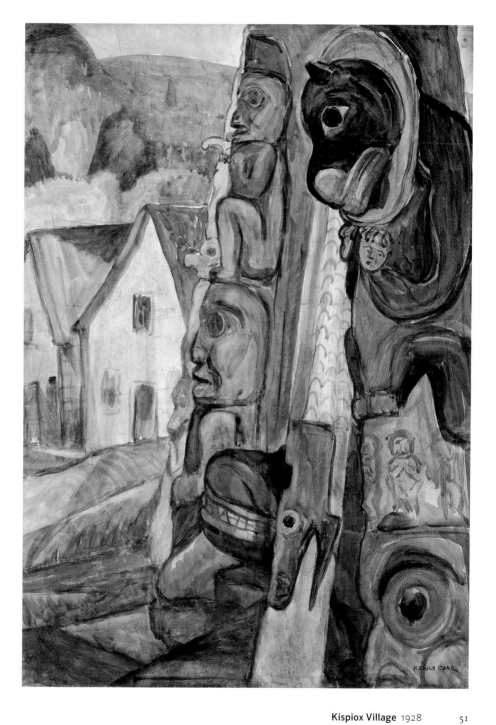

Kispiox Village 1928

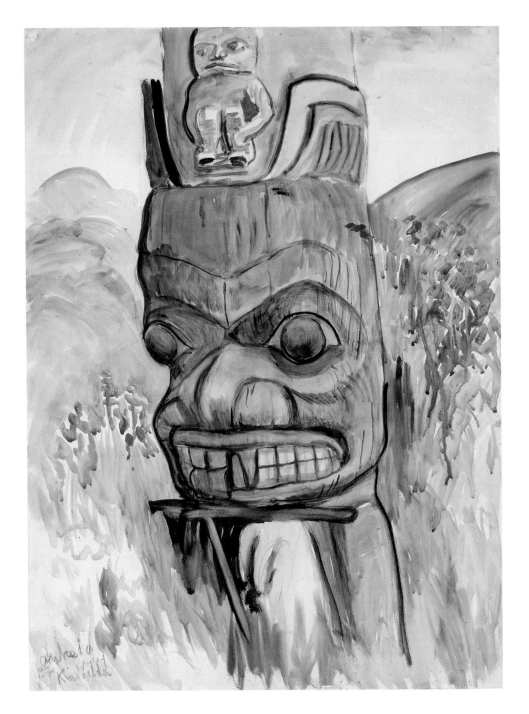

Ankeda, The Pole of Chief George Kindealda 1928

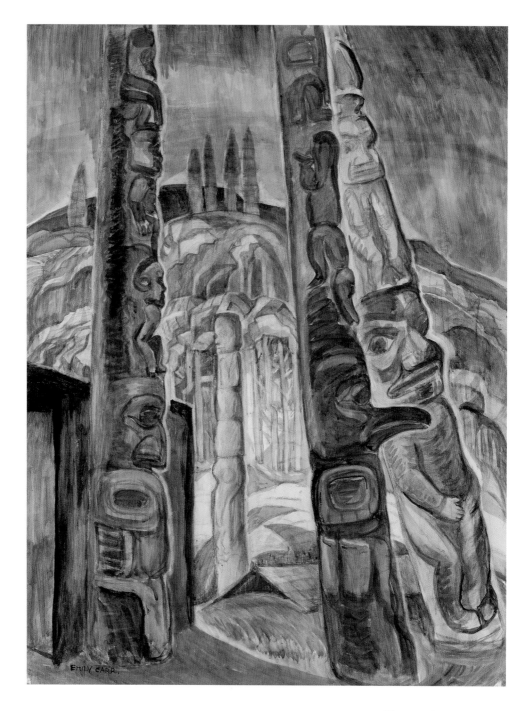

Kitwancool 1928 53

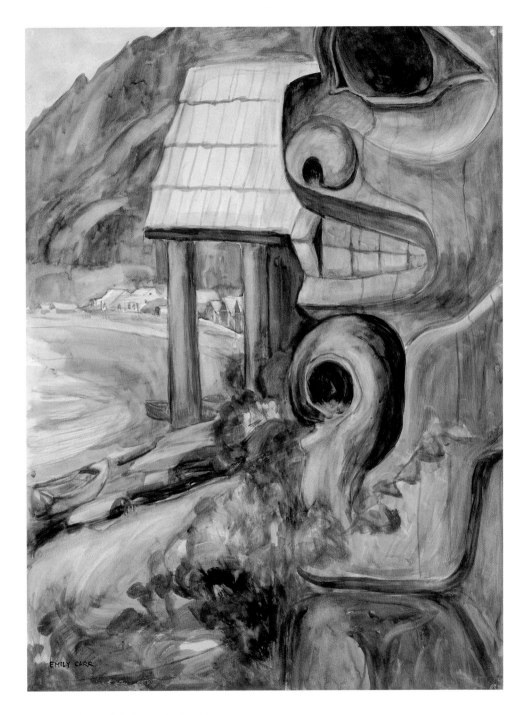

Beaver Pole, Skidegate 1928–29

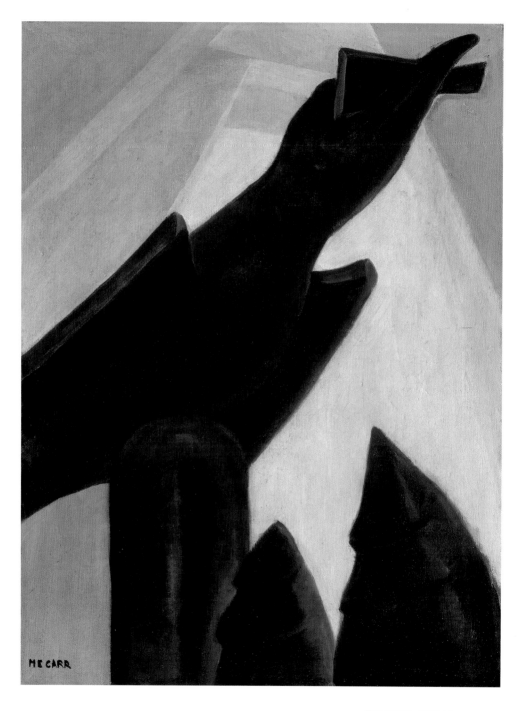

The Raven 1928–29 55

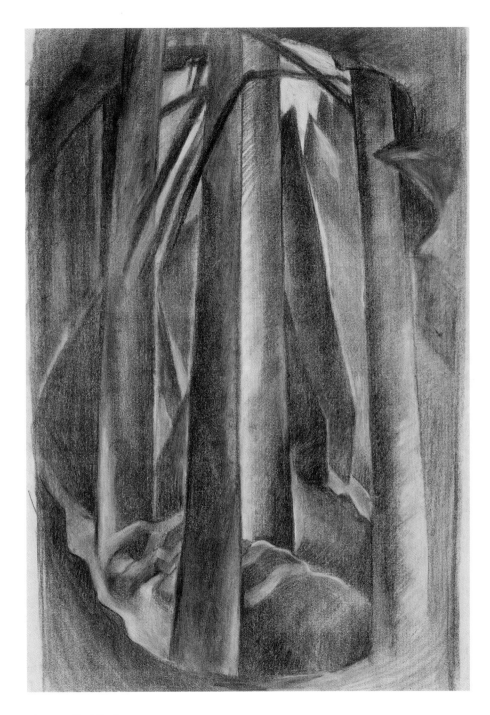

Port Renfrew 1929

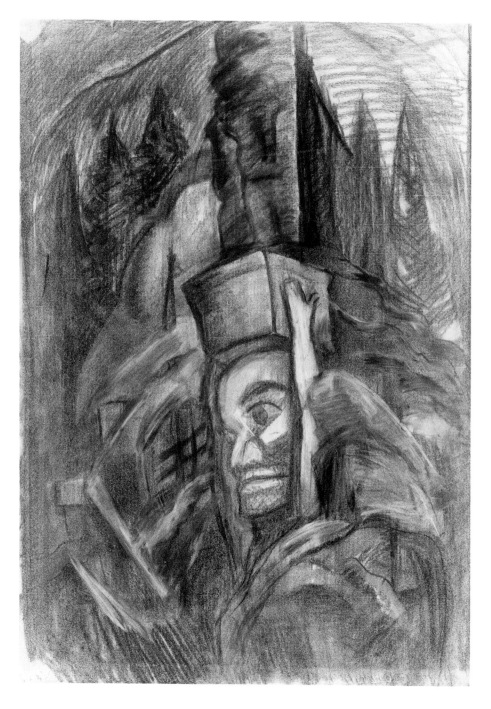

Agidal, Nass River C. 1929

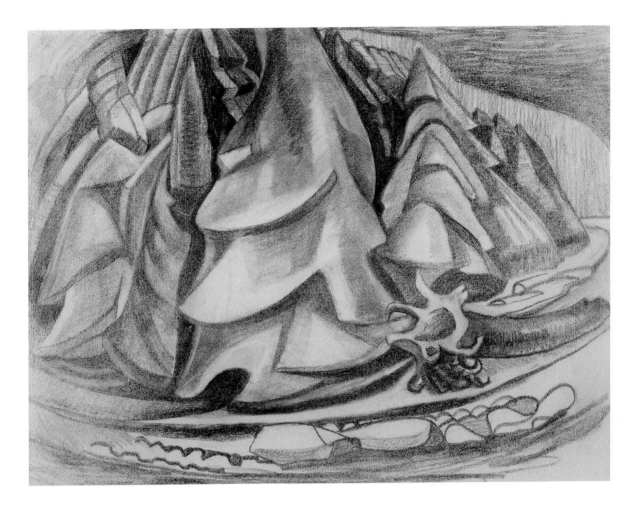

Untitled 1929

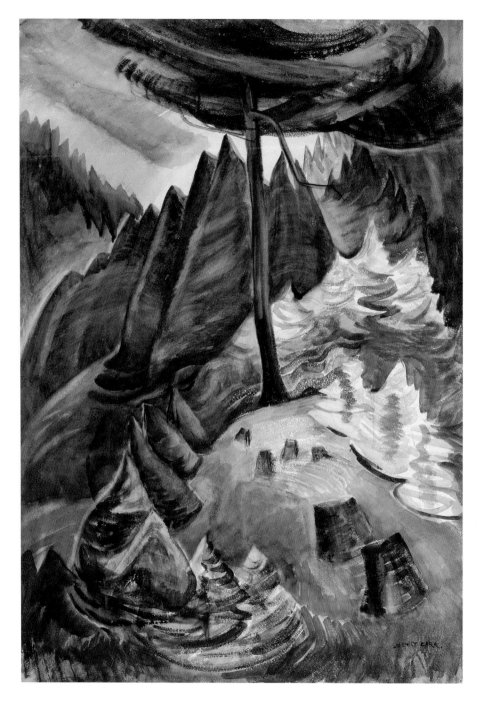

Pines in May 1929–30

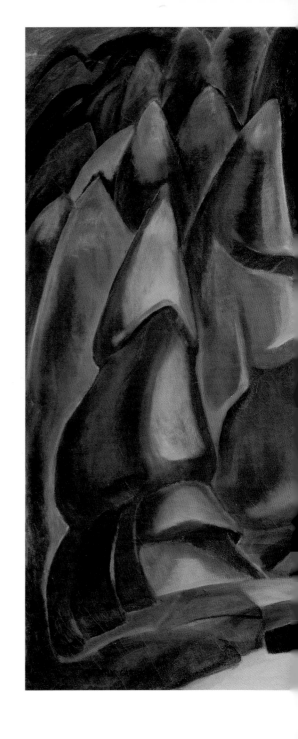

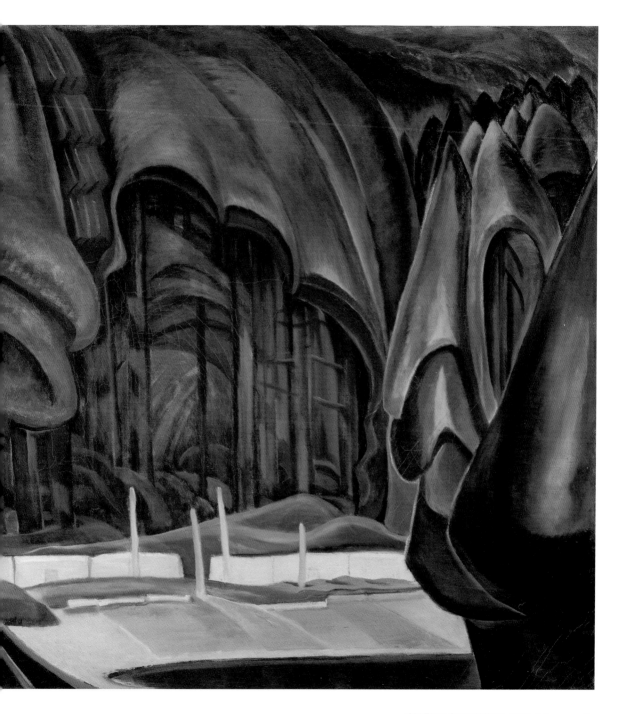

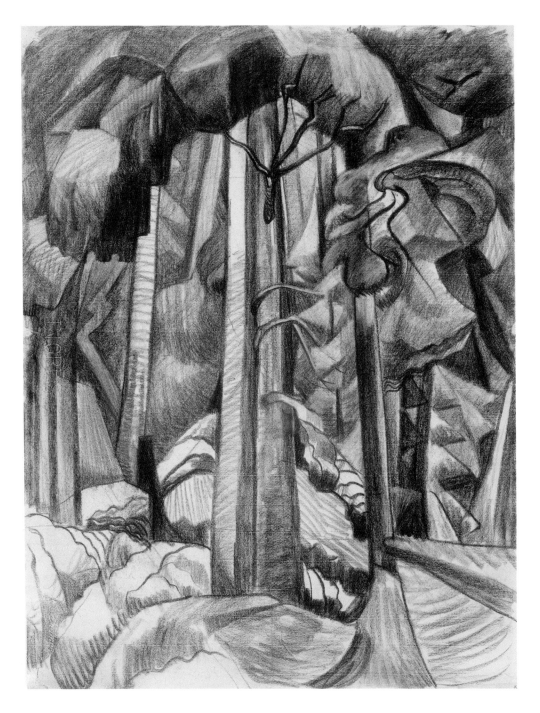

Untitled 1929–30

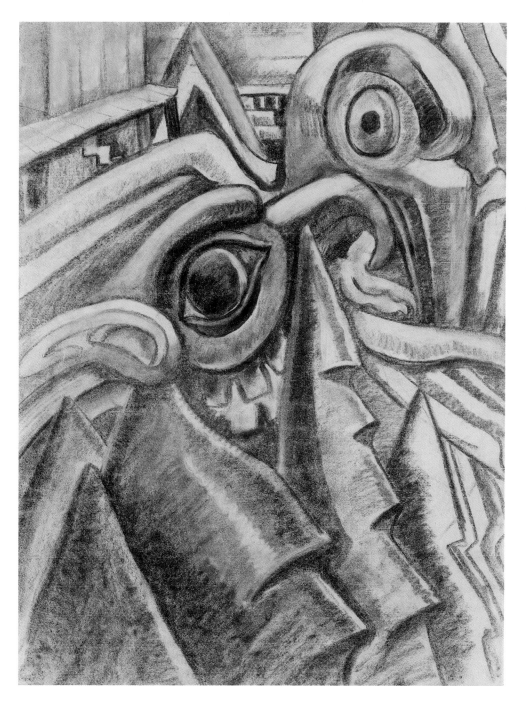

Untitled (formalized tree forms with totemic details) 1929–30

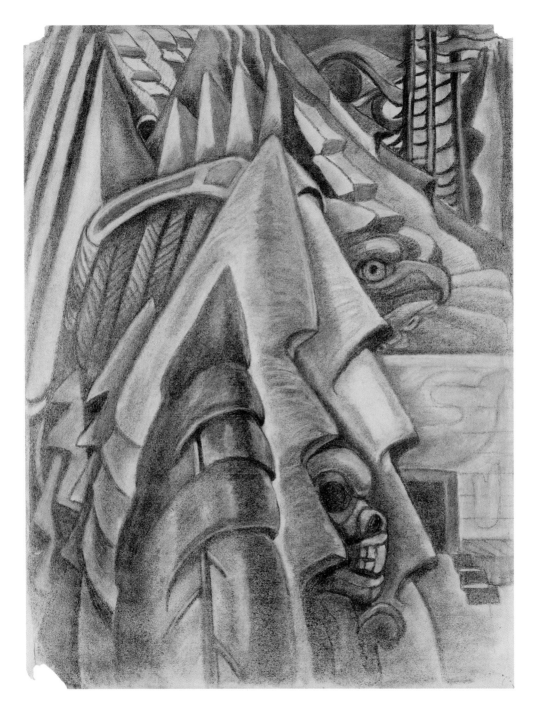

Untitled 1929–30

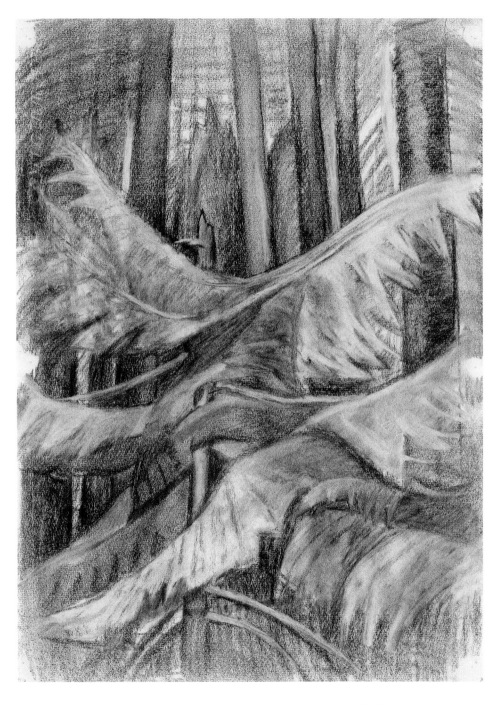

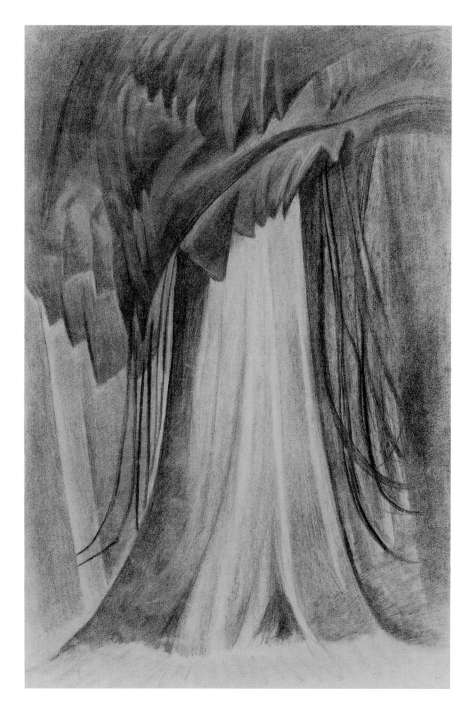

66 **Untitled** 1929–31

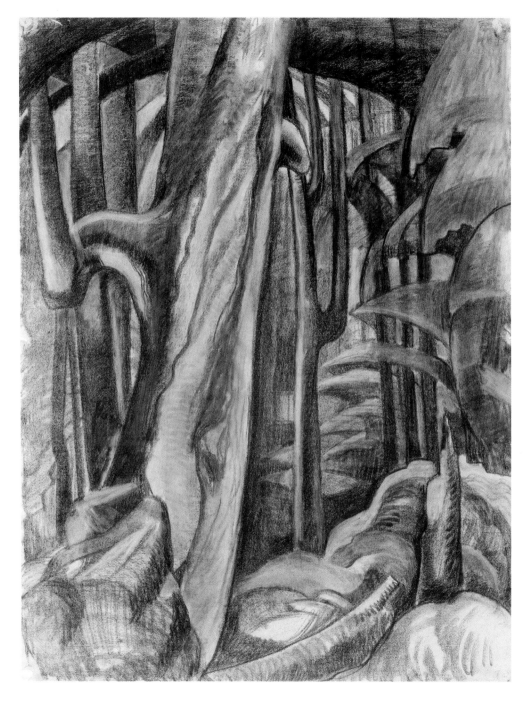

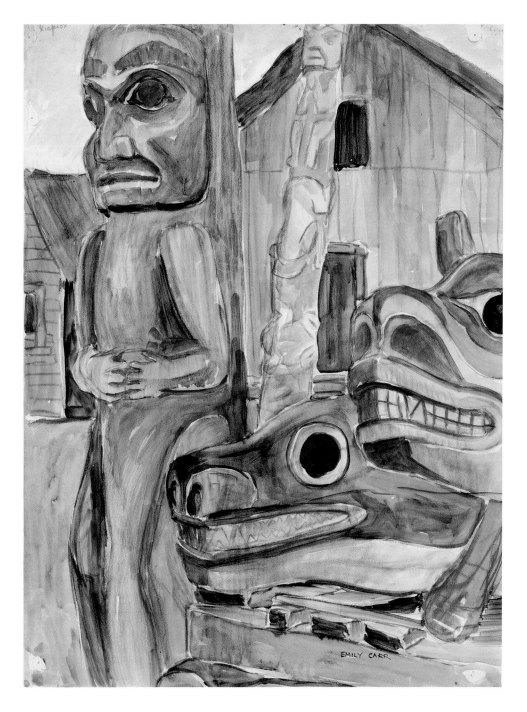

EMILY CARR

Kispiox 1928

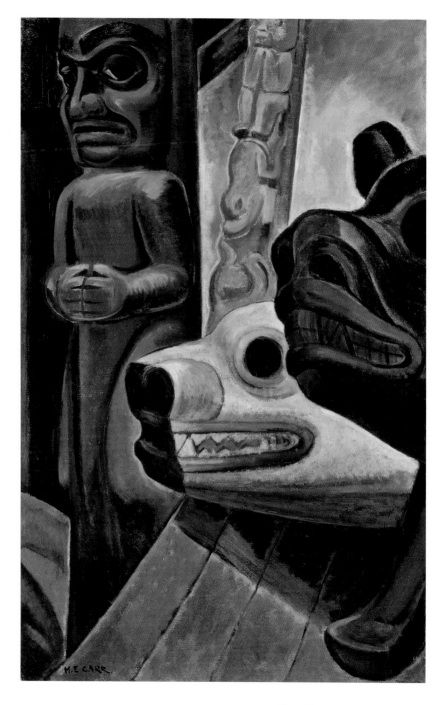

Untitled 1929–31

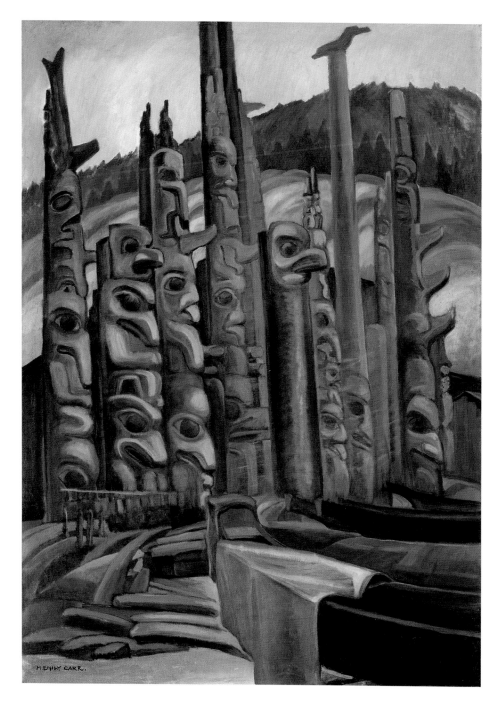

Totem Forest c. 1930 71

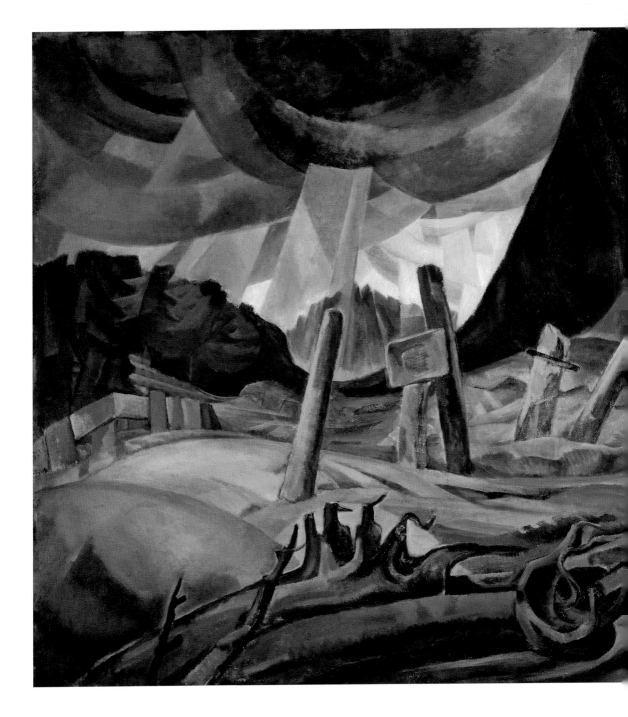

Vanquished 1930

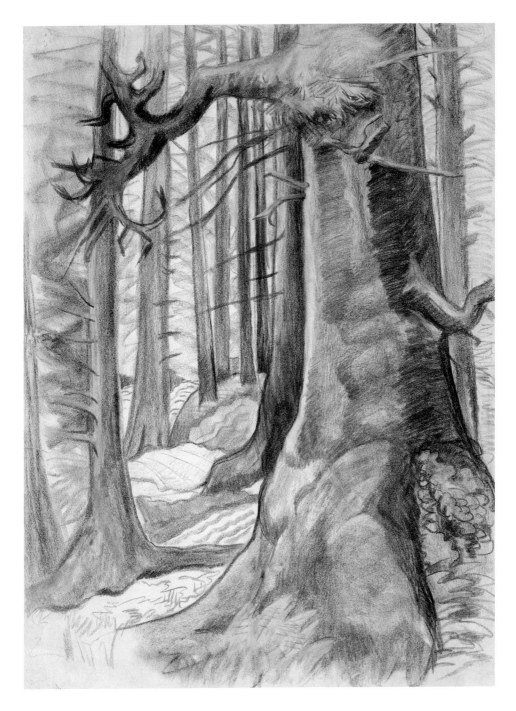

Friendly Cove C. 1930

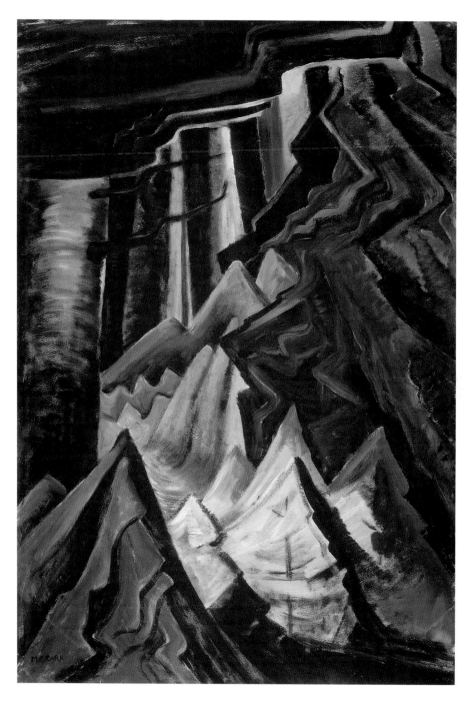

Untitled (Forest Interior, black, grey and white) C. 1930 75

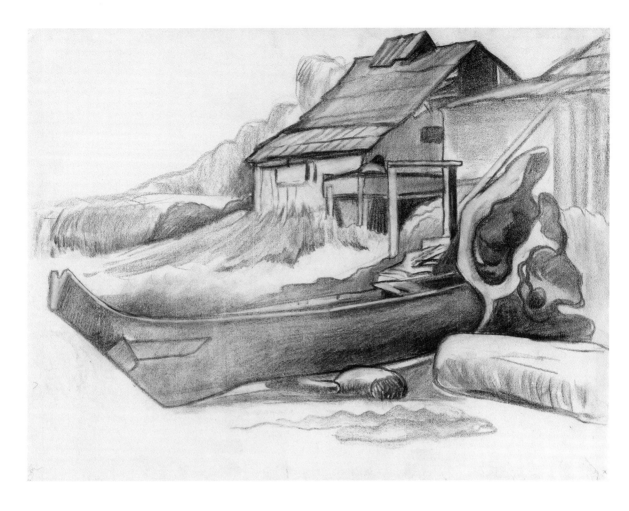

Friendly Cove c. 1930

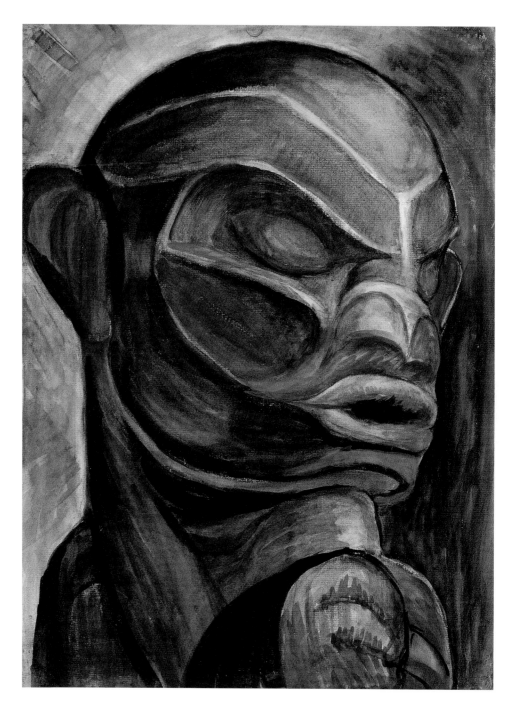

Zunoqua 1930

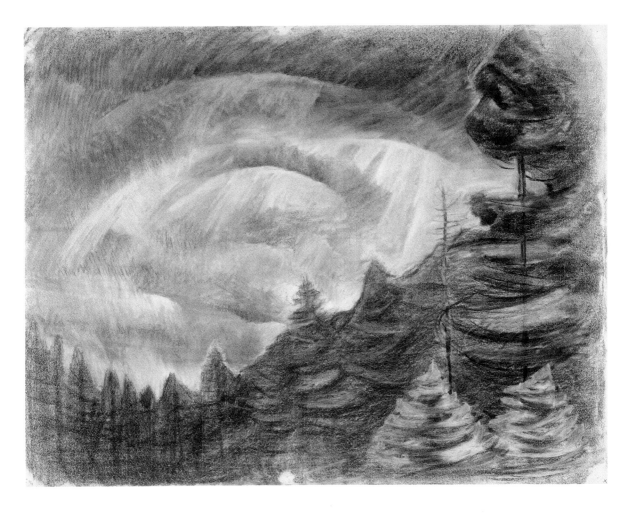

Untitled (landscape with "eye" in sky) 1930

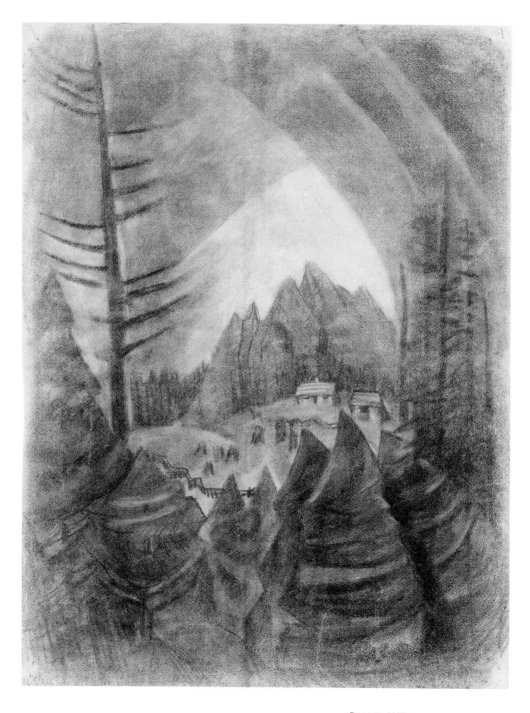

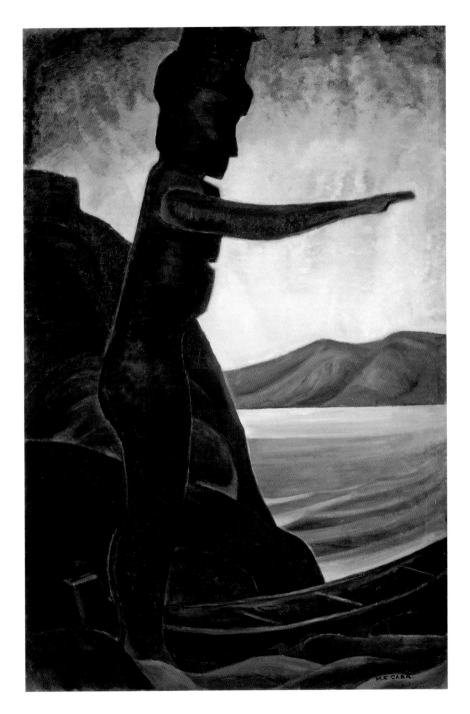

Silhouette No. 2 1930–31

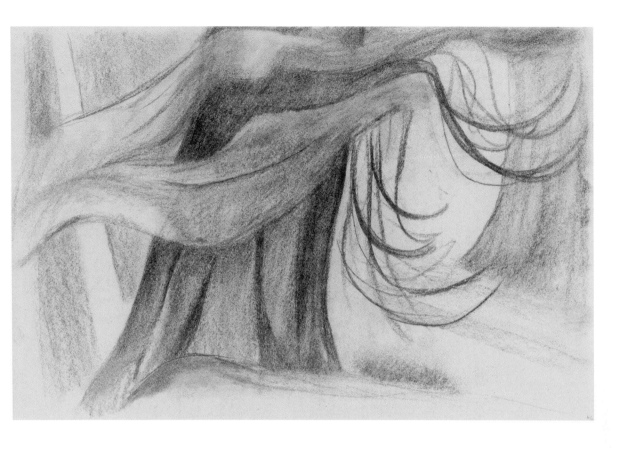

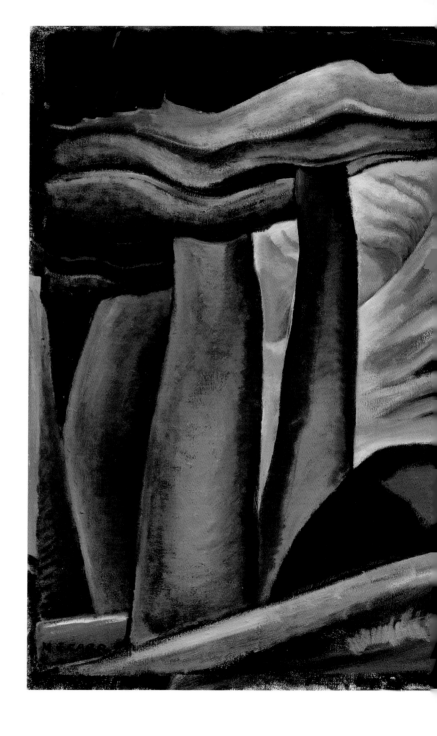

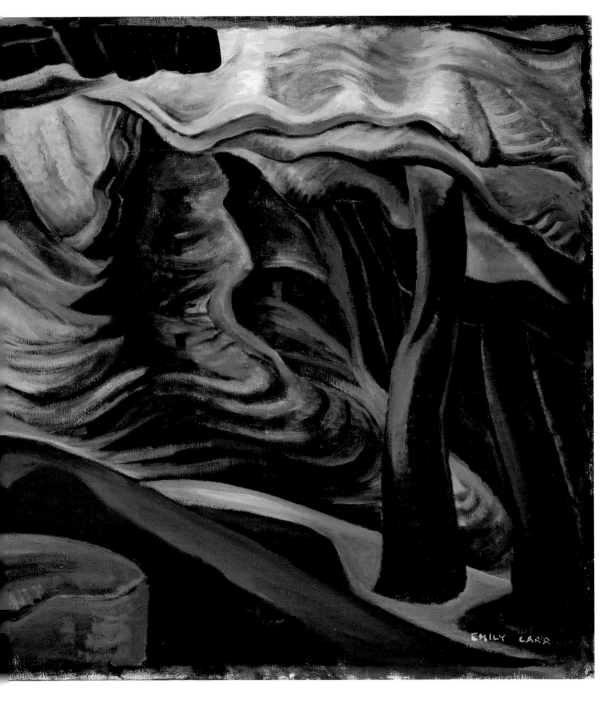

Deep Forest c. 1931

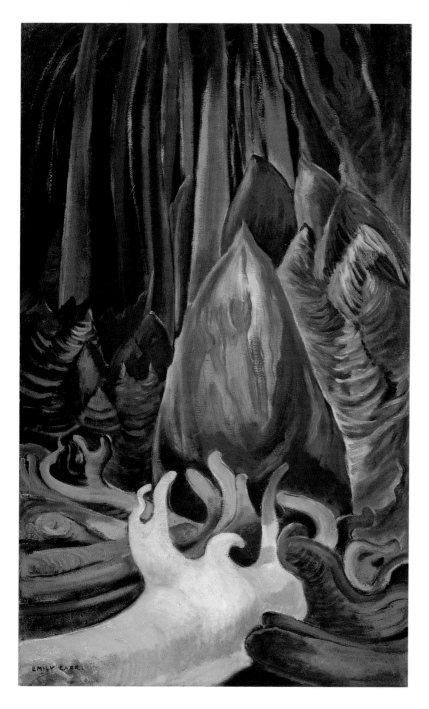

Sea Drift at the Edge of the Forest c. 1931

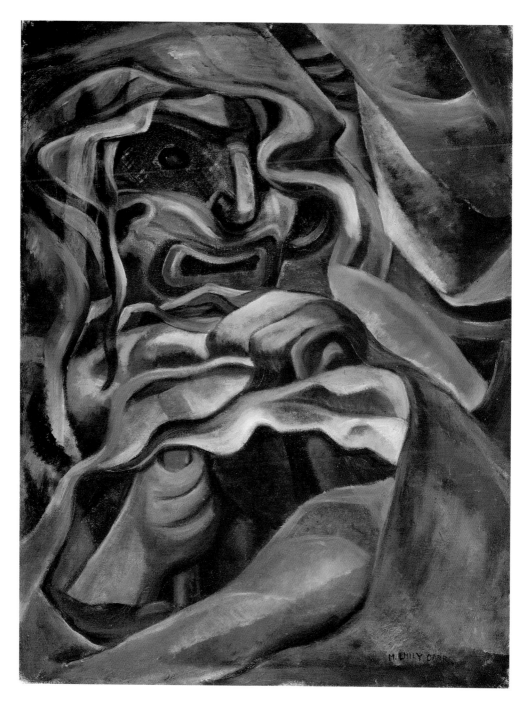

Strangled by Growth 1931

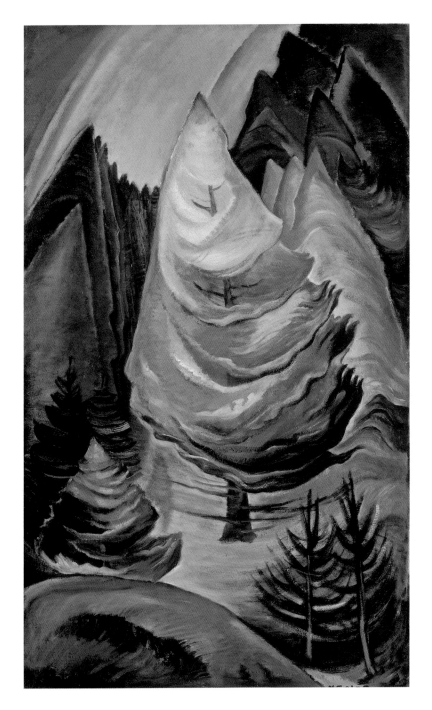

The Little Pine 1931

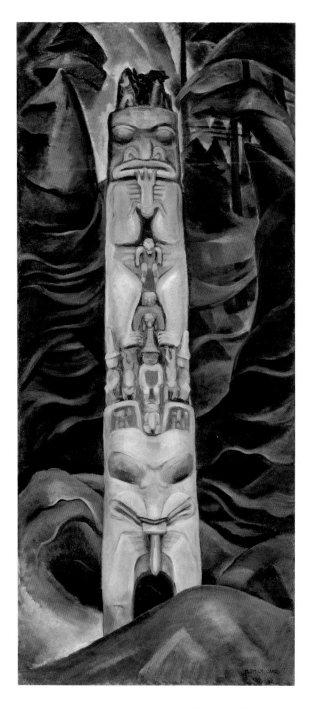

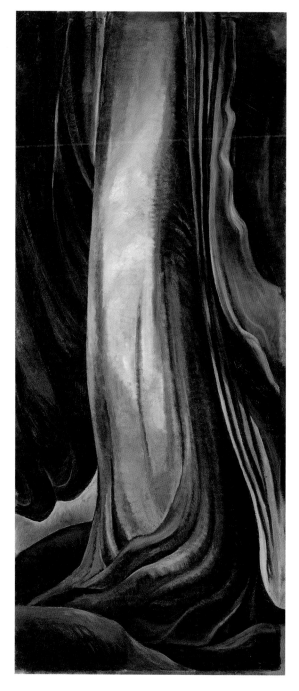

Totem and Forest 1931

Tree Trunk 1931

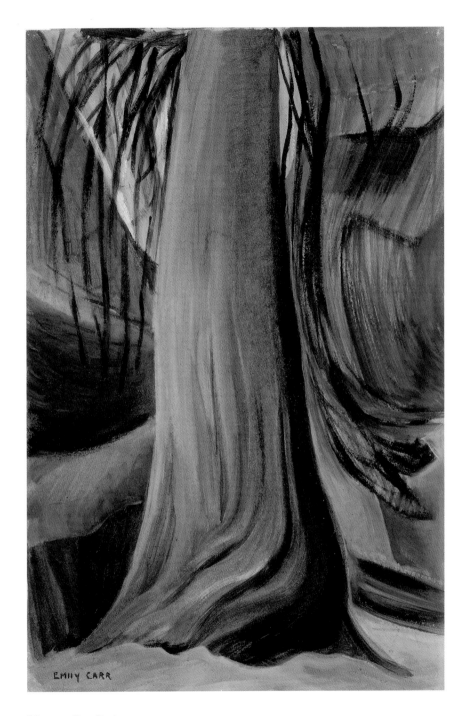

Tree Study c. 1930

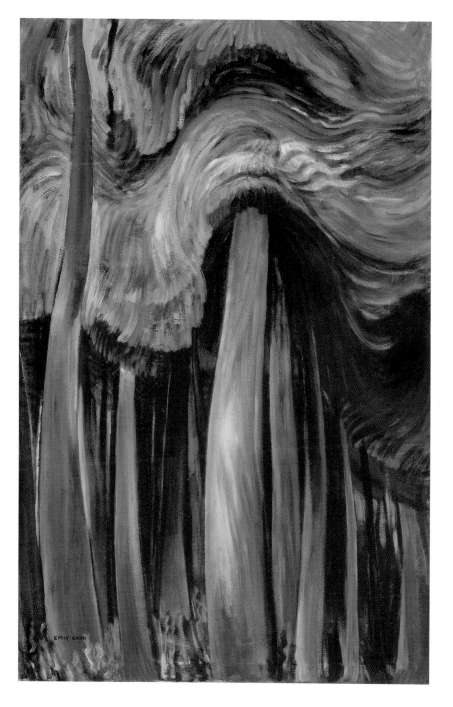

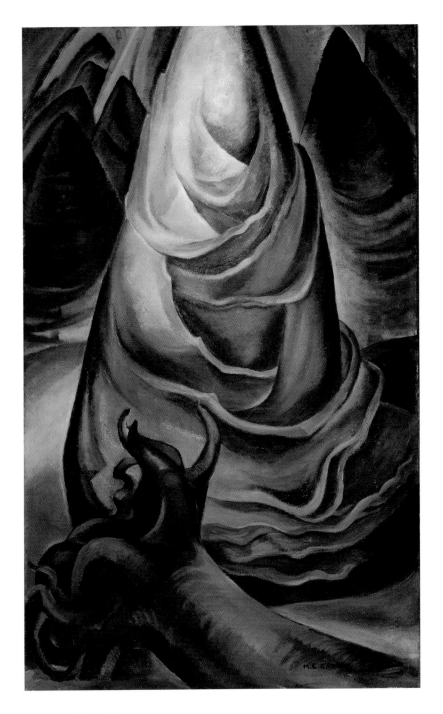

A Young Tree 1931

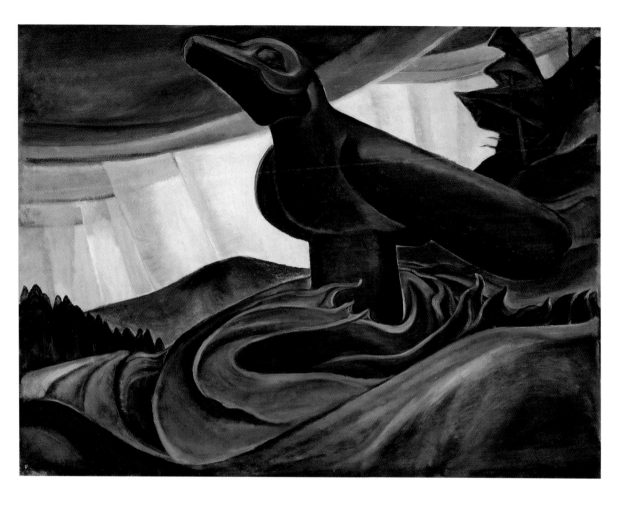

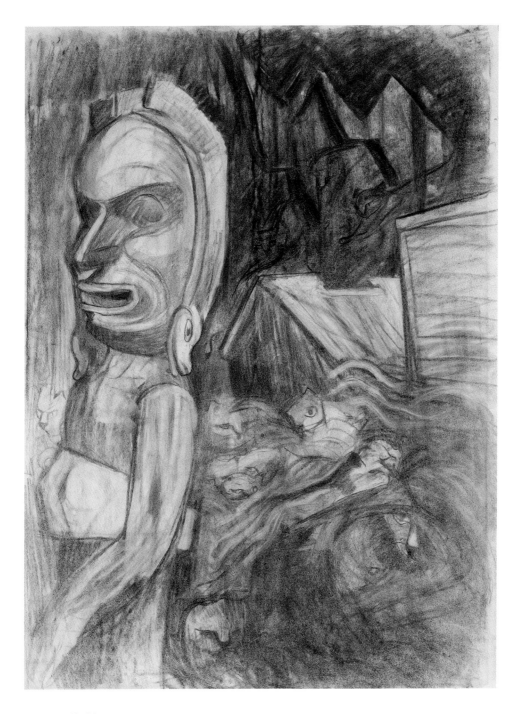

Koskimo 1930

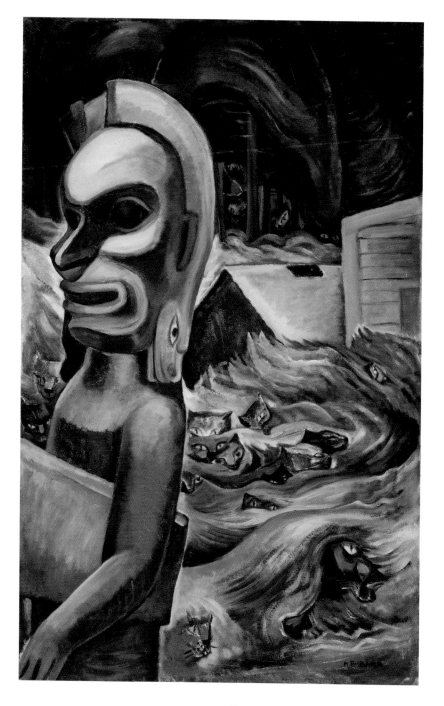

Zunoqua of the Cat Village 1931

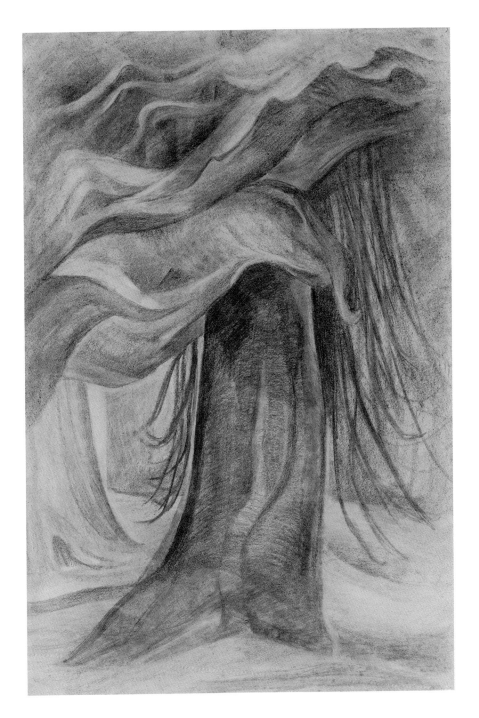

Untitled (Tree) 1931–32

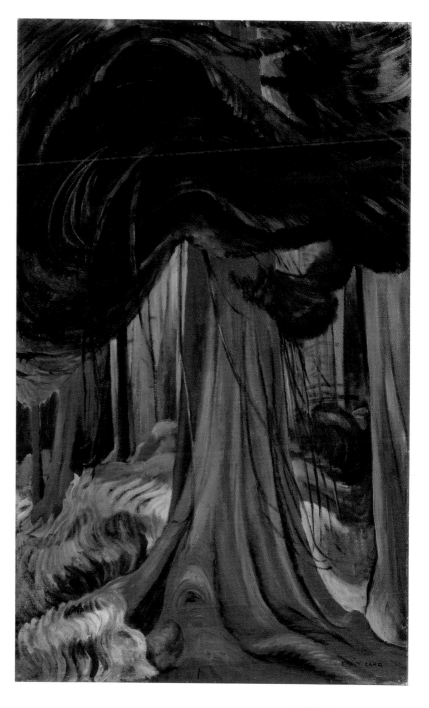

Red Cedar 1931

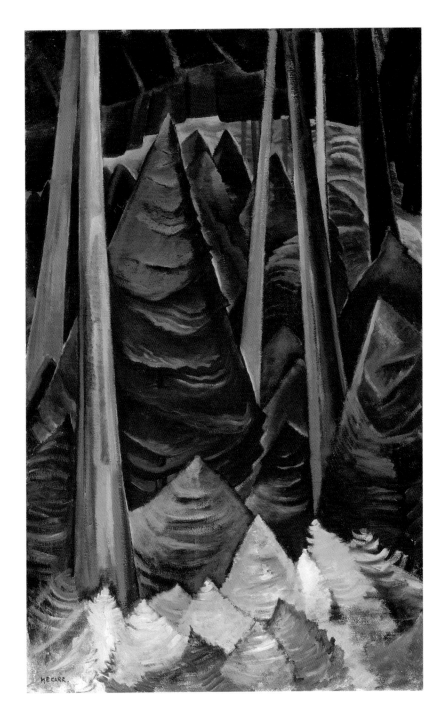

Old and New Forest 1931–32

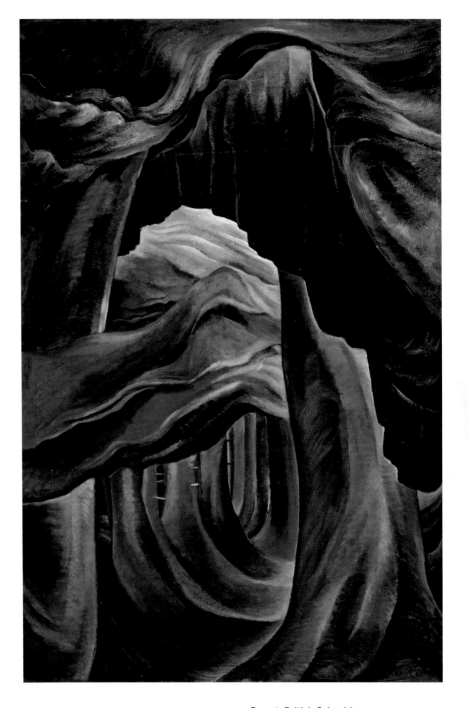

Forest, British Columbia 1931–32 97

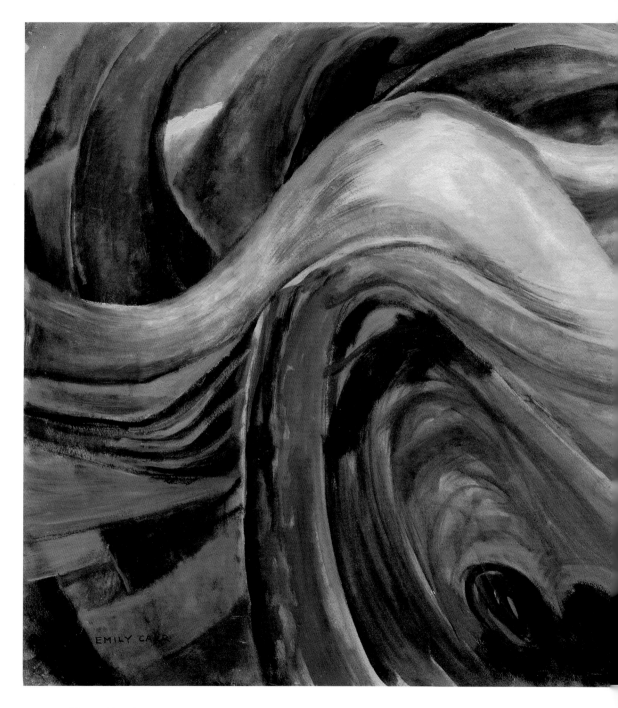

Abstract Tree Forms 1931–32

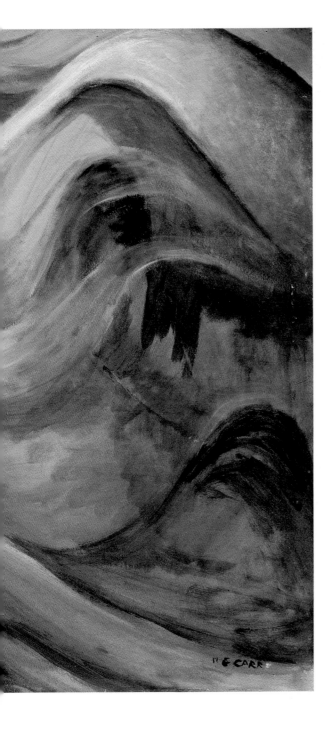

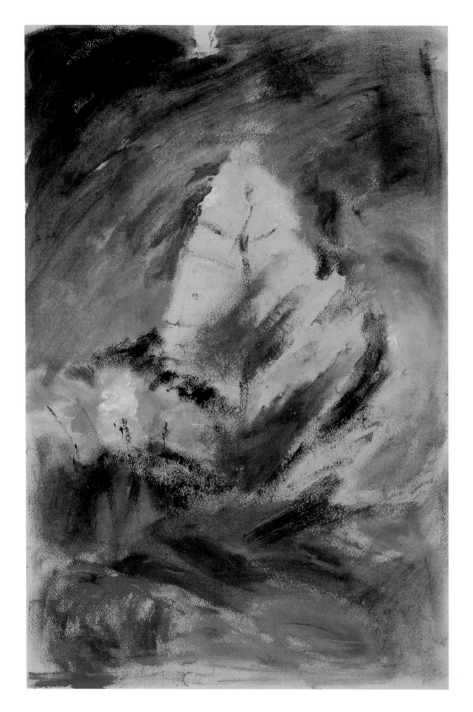

Untitled 1931–32

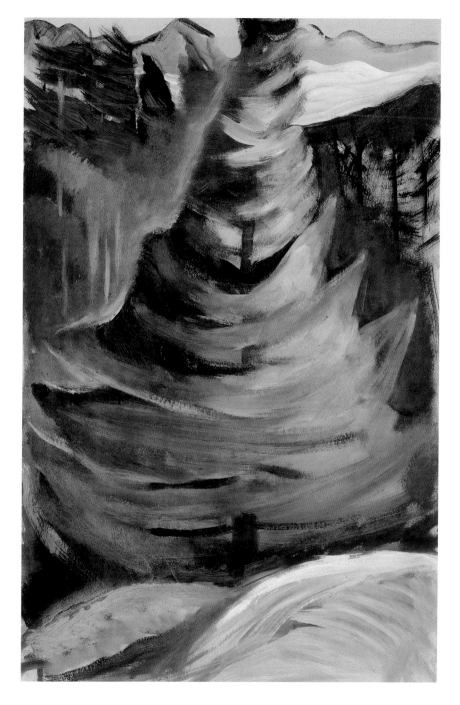

Untitled 1931–32

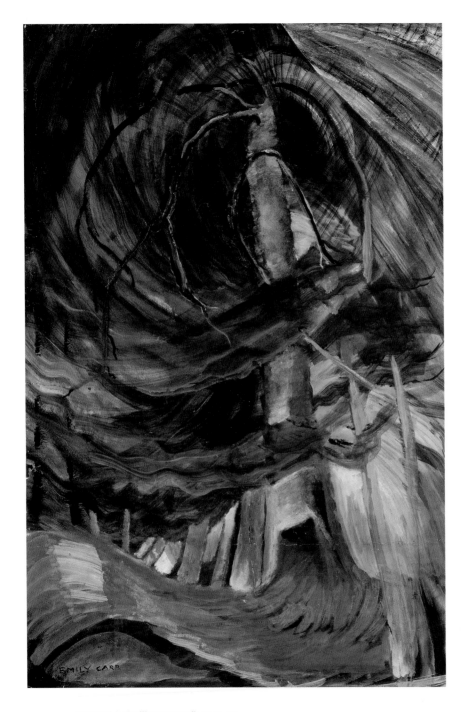

Untitled (spiralling upward) 1932–33

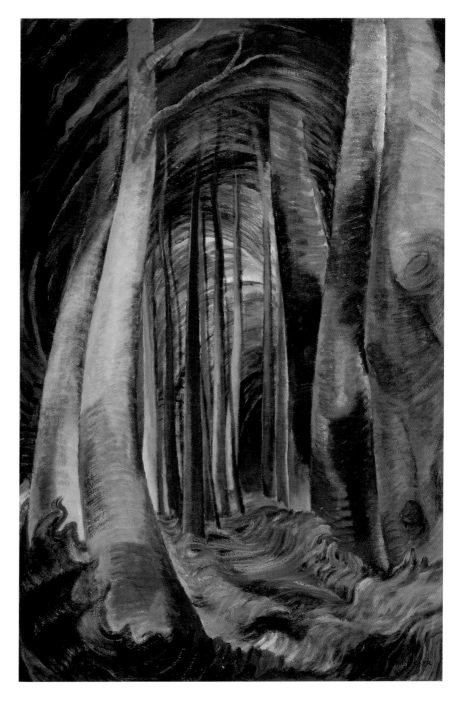

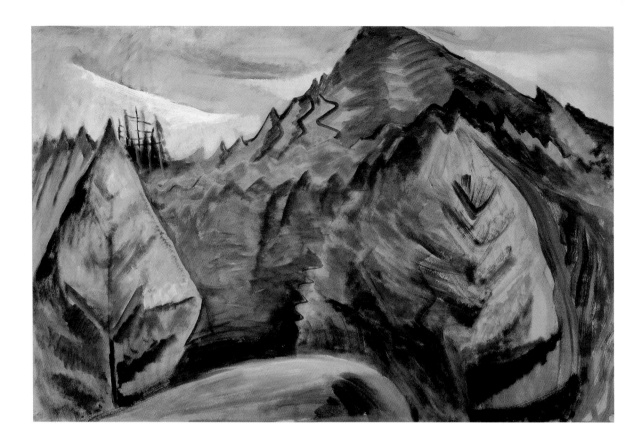

104 **Untitled** 1932-33

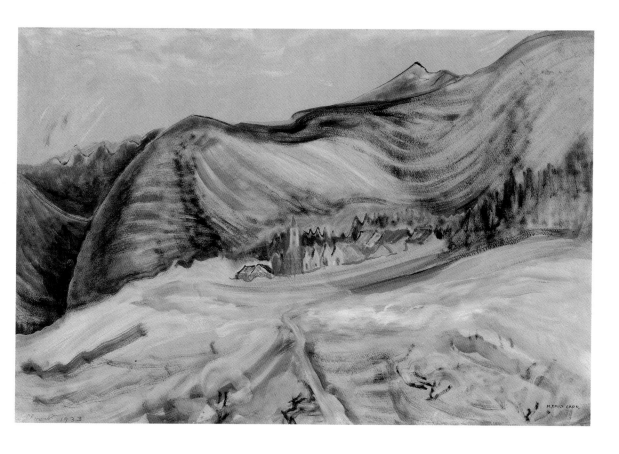

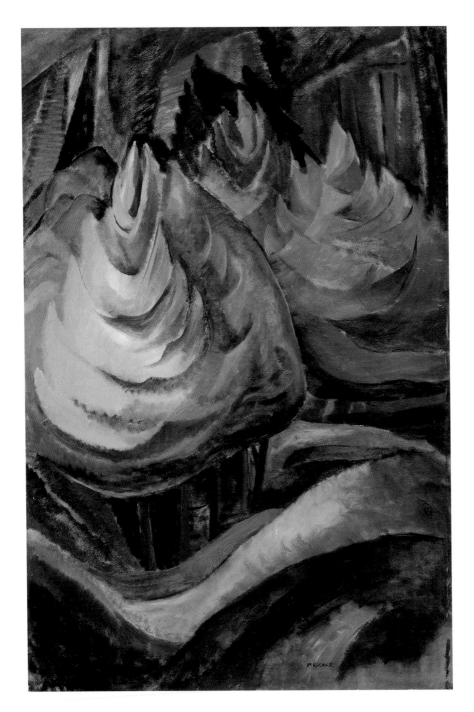

Formalized Trees, Spring c. 1933

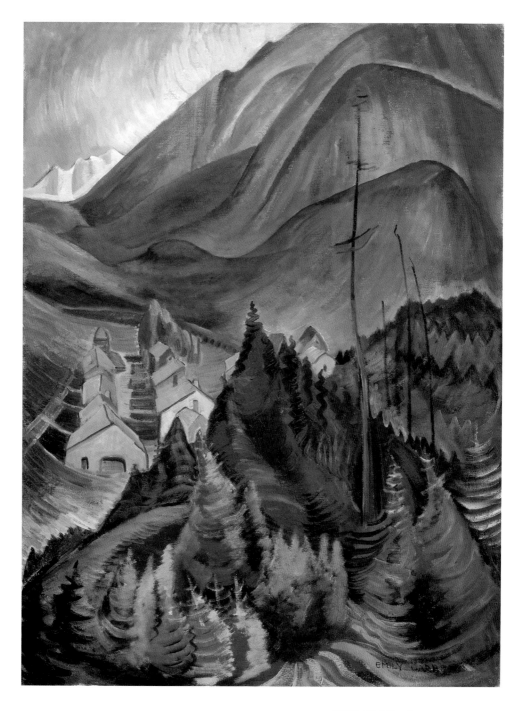

Pemberton Meadows 1933 107

Untitled 1933–34

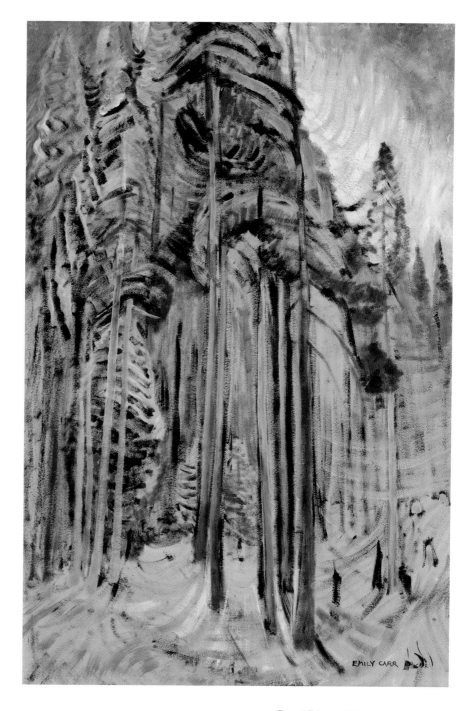

Forest Edge and Sky c. 1934

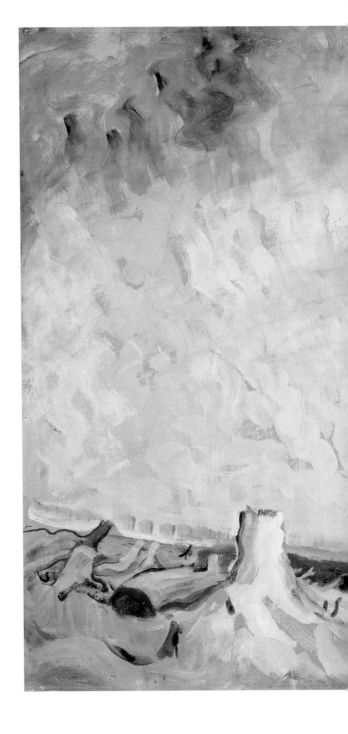

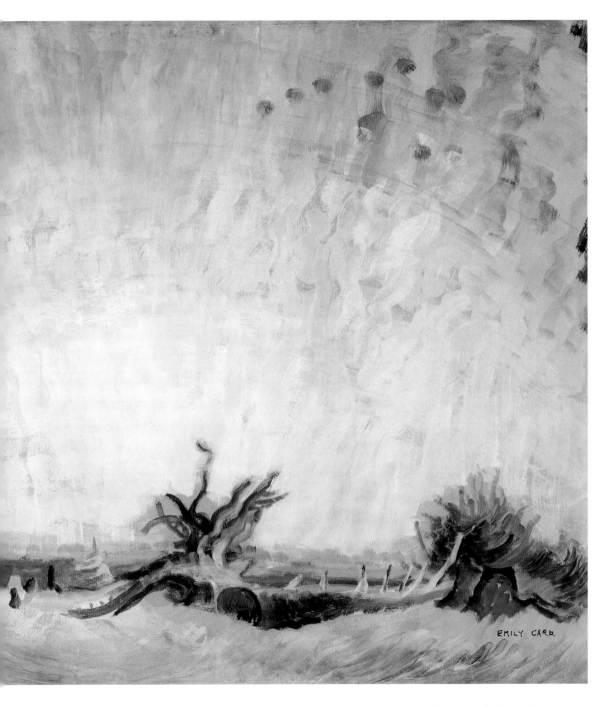

Stumps and Sky c. 1934

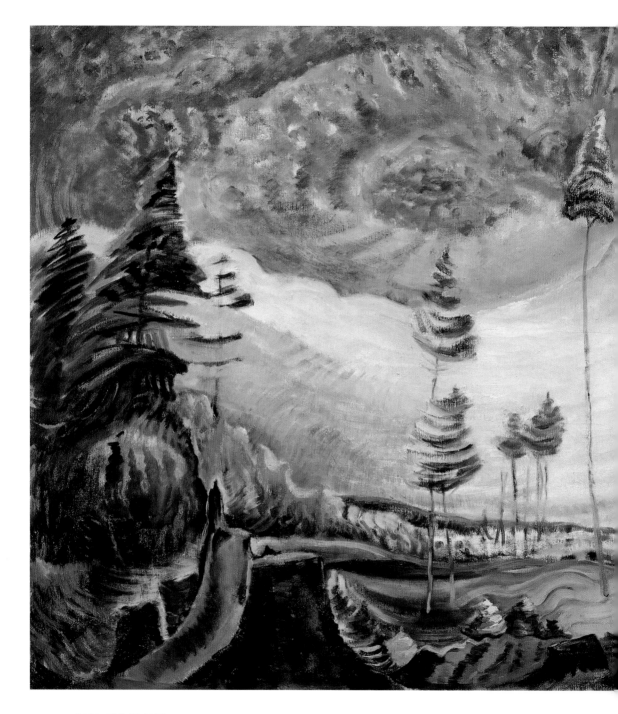

Loggers' Culls 1935

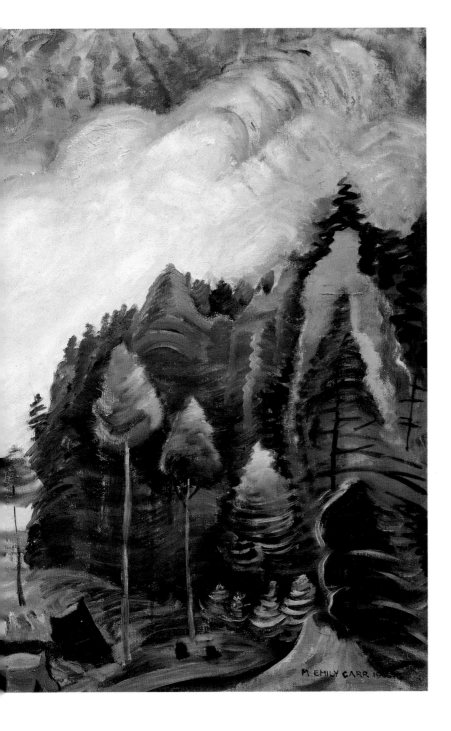

M. EMILY CARR 19

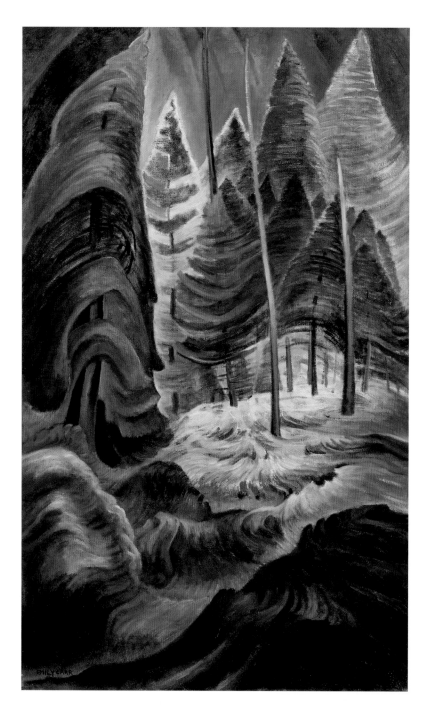

A Rushing Sea of Undergrowth 1935

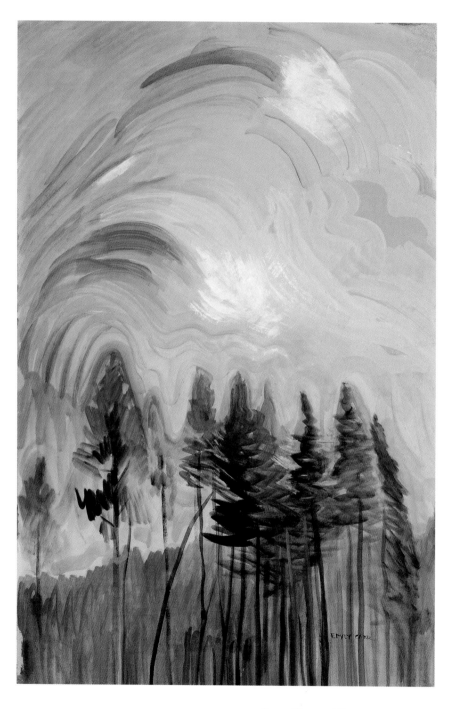

Young Pines and Sky c. 1935

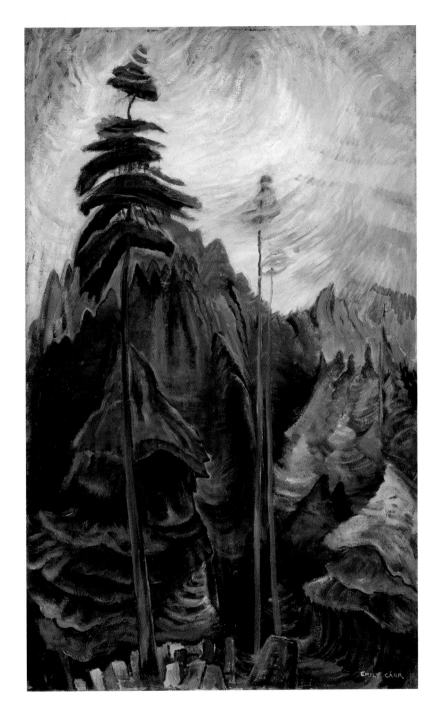

Mountain Forest 1935-36

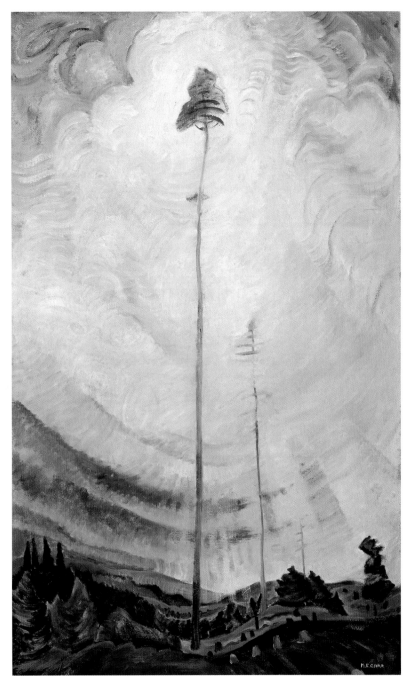

Scorned as Timber, Beloved of the Sky 1935 119

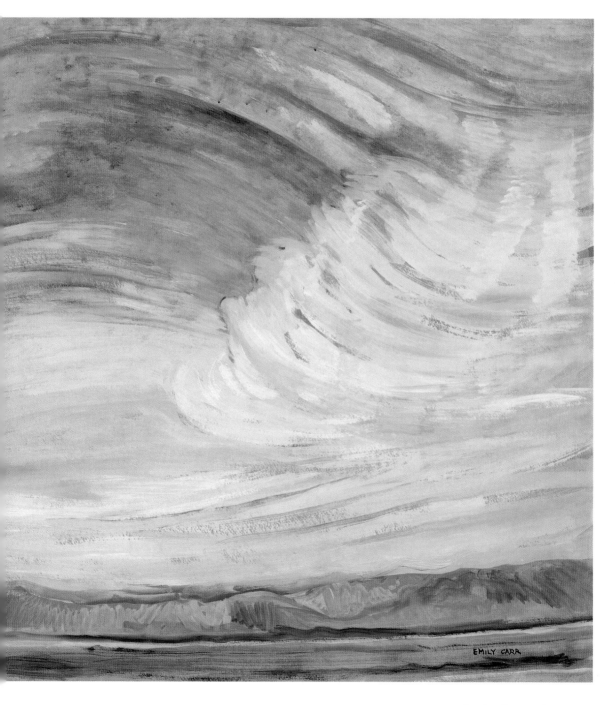

Overhead 1935-36

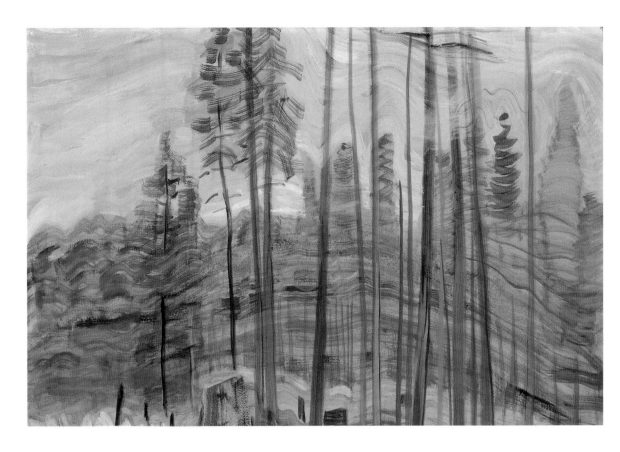

Untitled (Forest) c. 1936

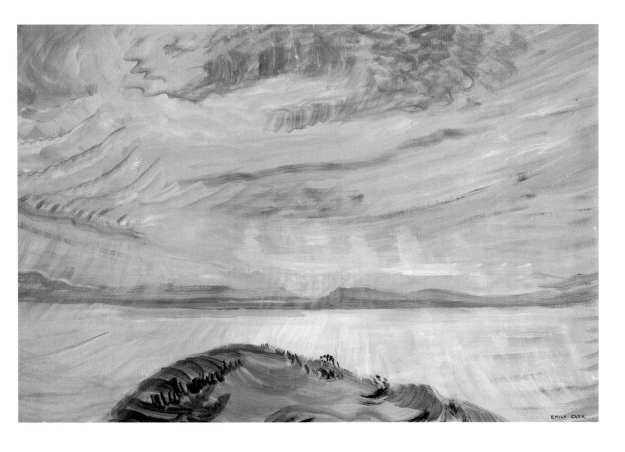

Victoria Sight across the Water C. 1937 123

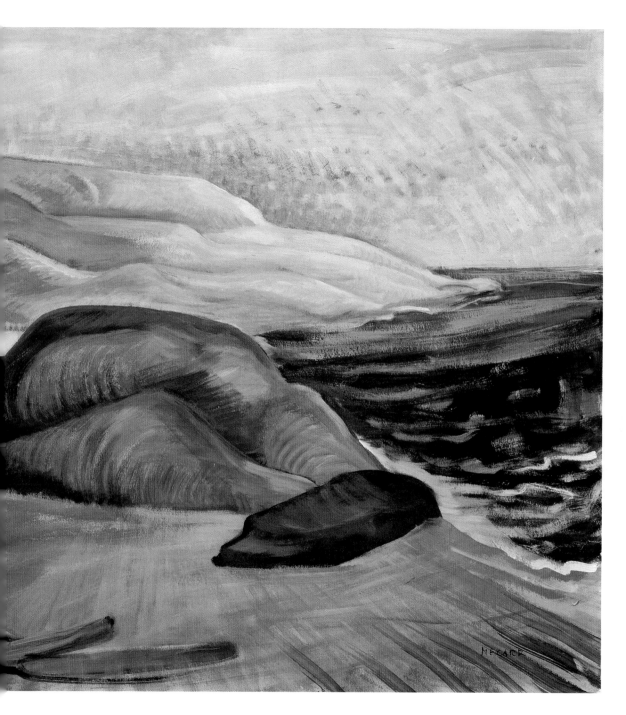

The Coast of Juan de Fuca c. 1936

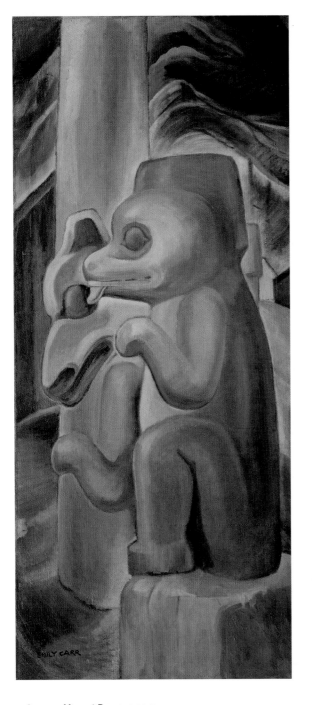

Masset Bears c. 1941

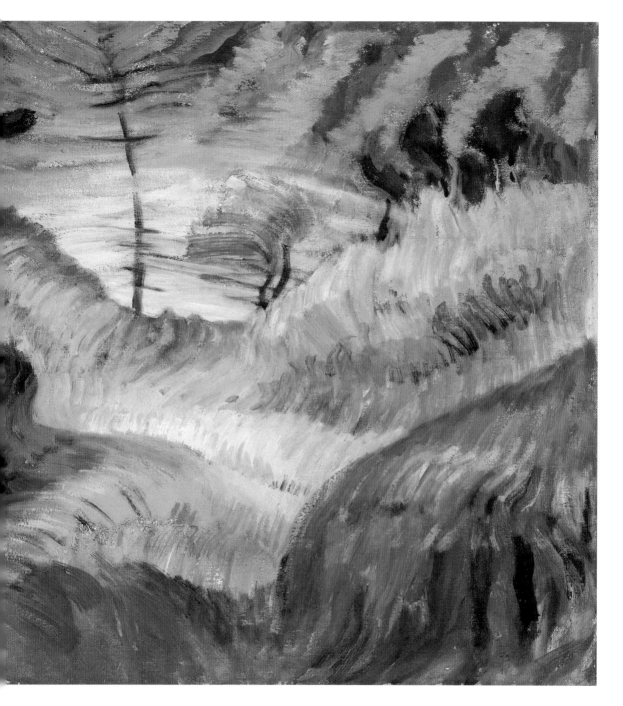

Untitled (Rhythm of Nature) C. 1937

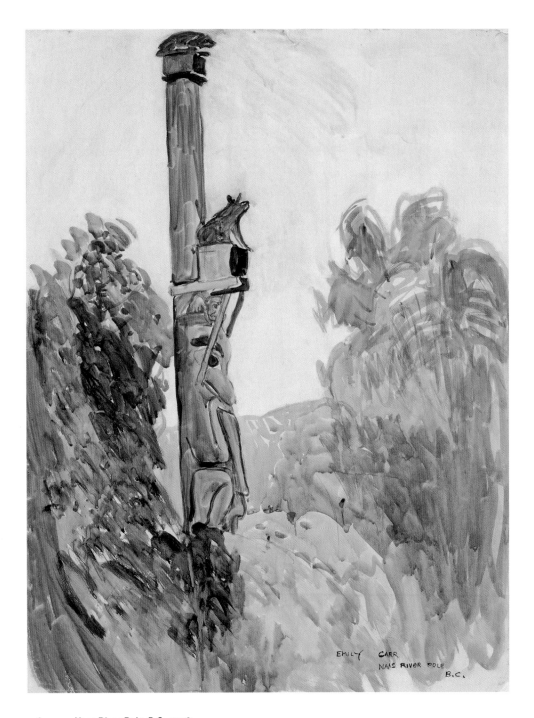

EMILY CARR
NAAS RIVER POLE
B.C.

Nass River Pole, B.C. 1928

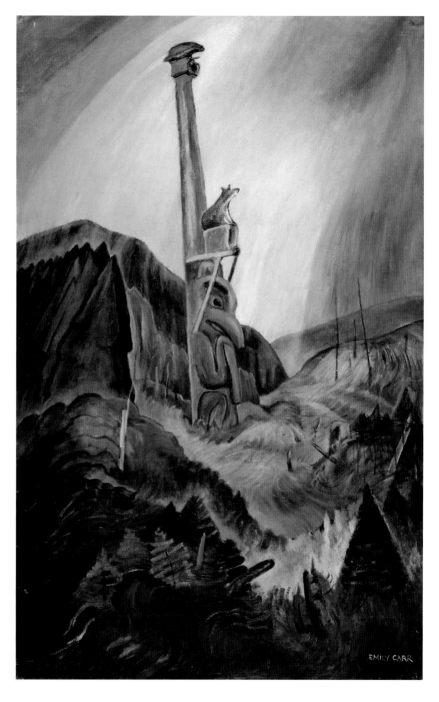

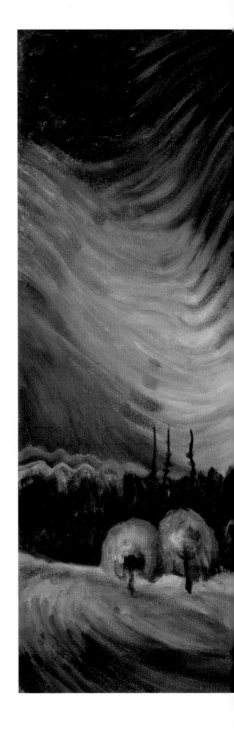

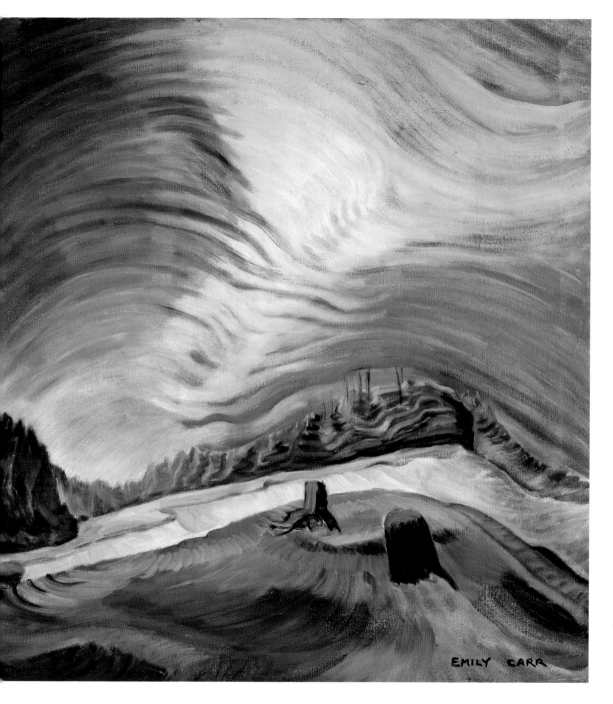

Above the Gravel Pit 1937

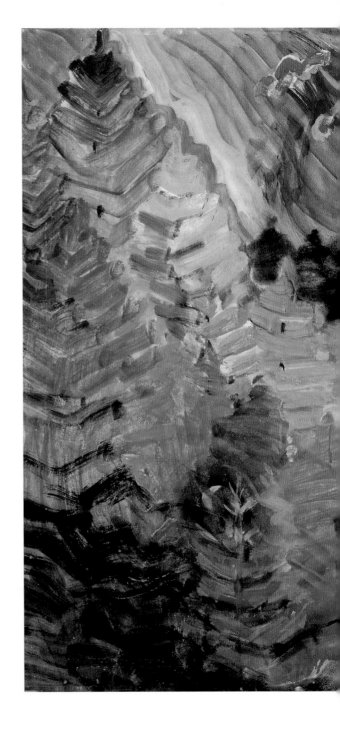

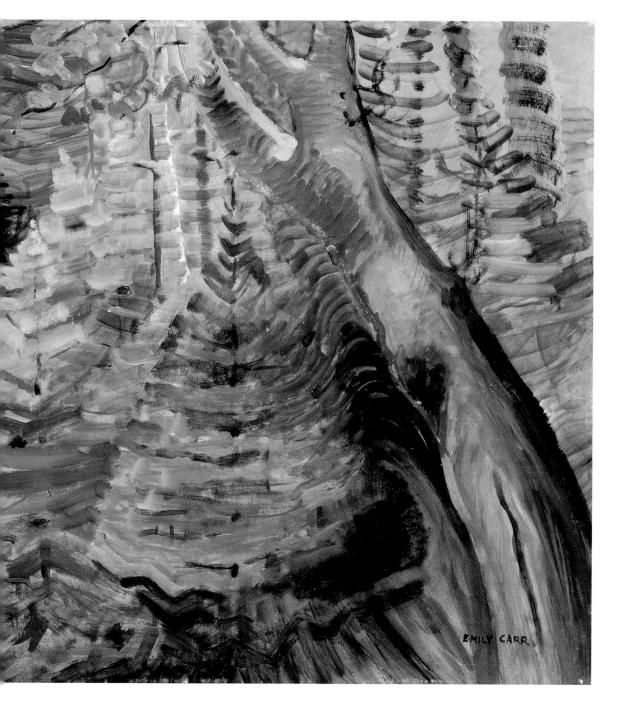

Young Pines and Old Maple 1937-38 133

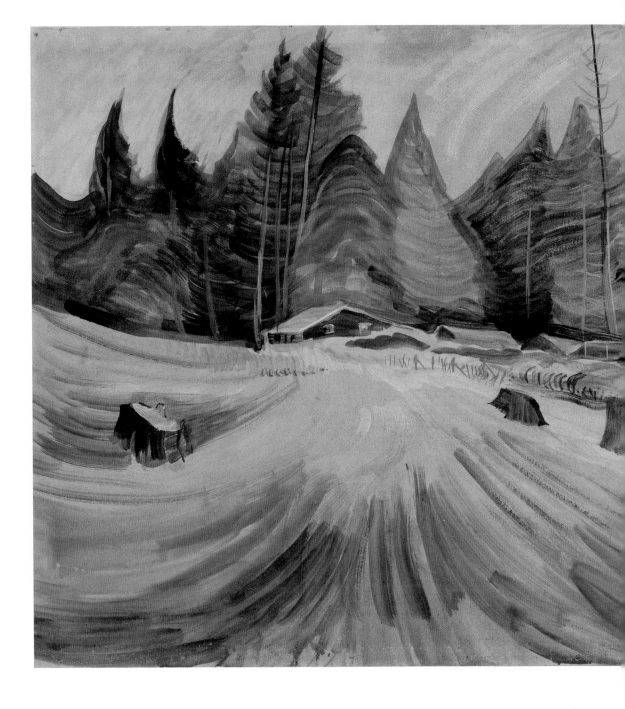

Mrs. Jones' Farm C. 1938

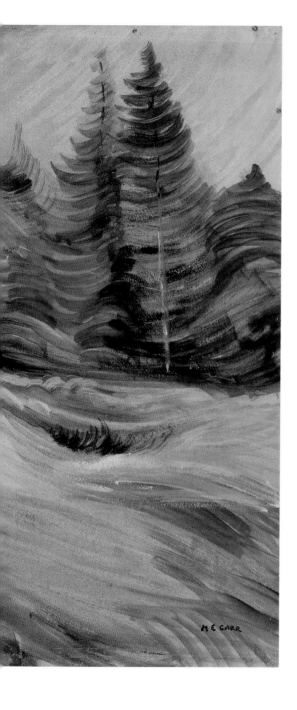

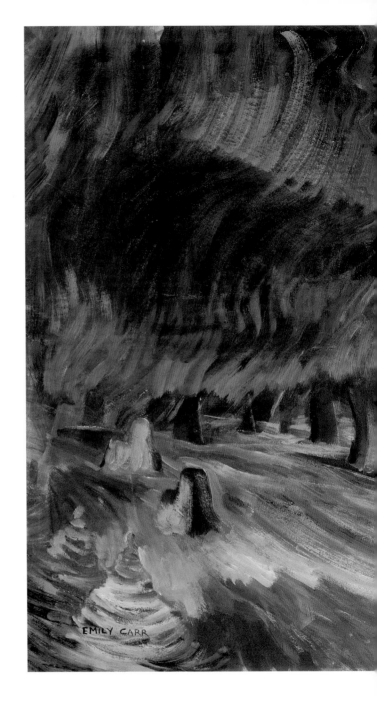

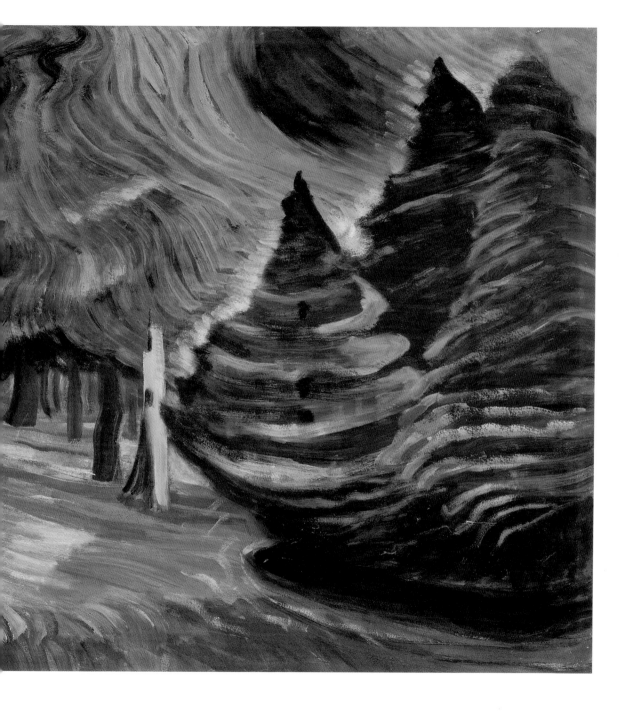

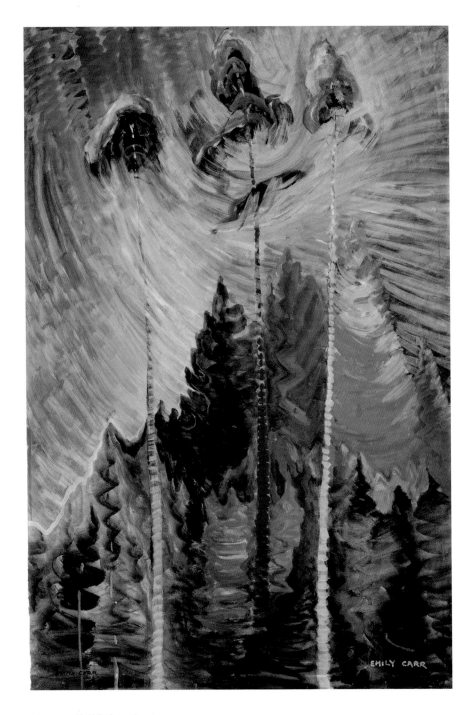

138 **Untitled** 1938-39

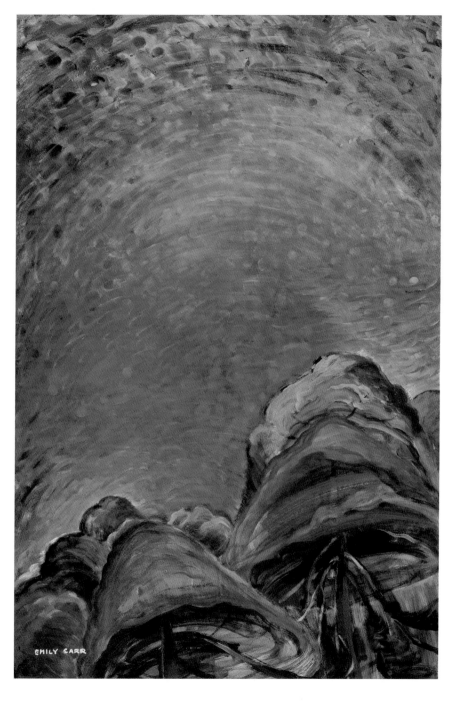

Above the Trees c. 1939

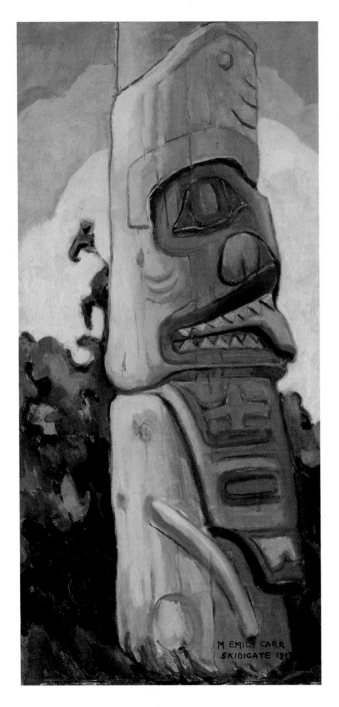

Skidegate (Shark Pole) 1912

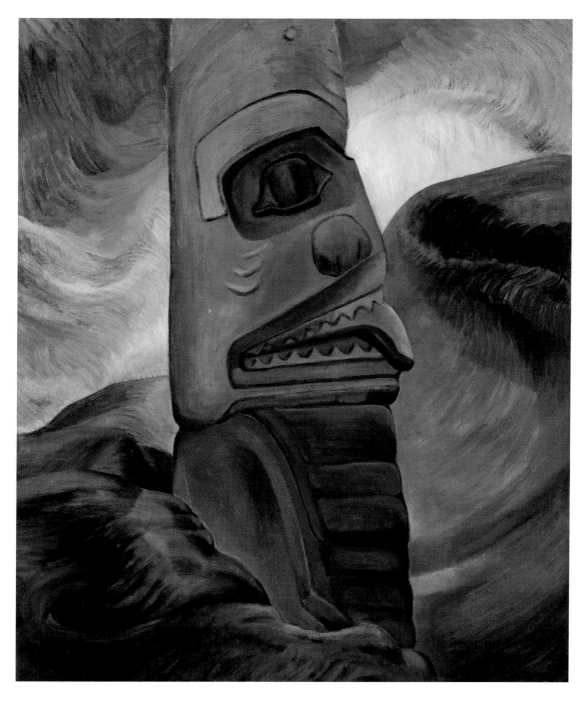

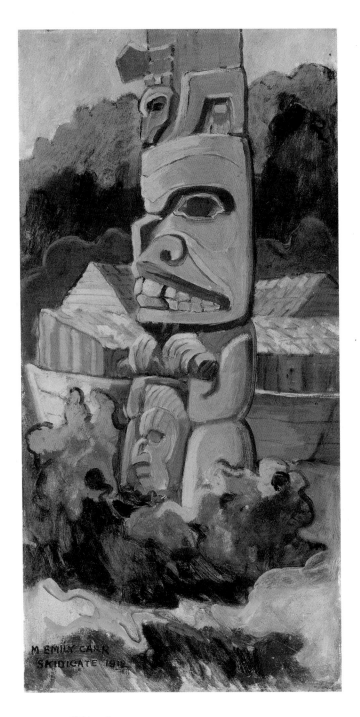

Skidegate 1912

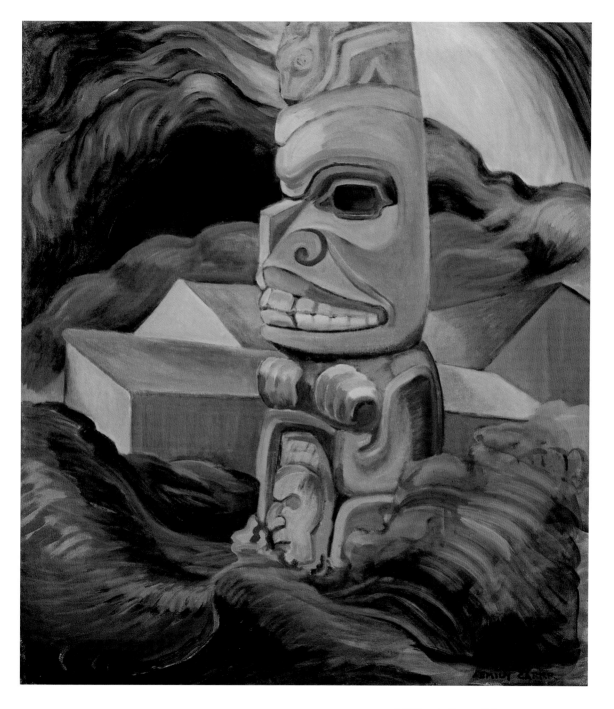

A Skidegate Beaver Pole 1941-42 143

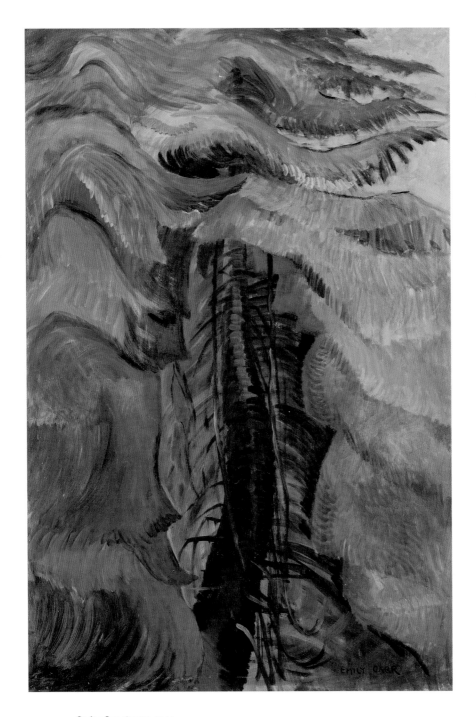

Cedar Sanctuary 1942

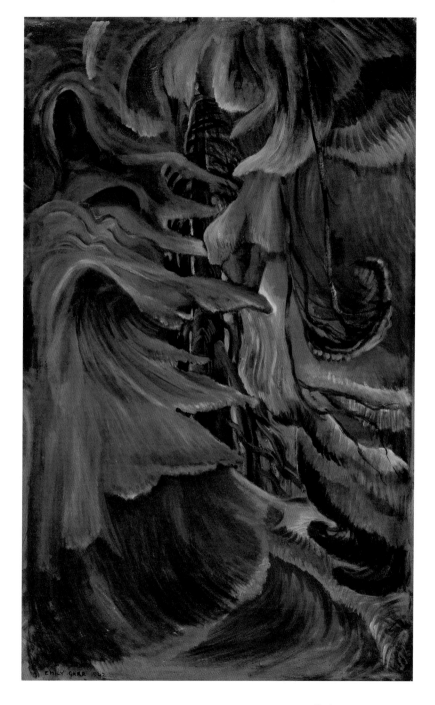

List of works

Snowdrops c. 1894, ink on wood, 8.8 × 5.8 cm, Collection of the Vancouver Art Gallery, Gift of Irina Carlsen-Reid, VAG 98.42.1.

Victoria Sketchbook 1898, ink on paperboard, 8 × 5 cm, Collection of the Vancouver Art Gallery, Gift of Dr. John Parnell, VAG 83.34.

Chrysanthemums c. 1900, oil on canvas, 43.8 × 34.9 cm, Collection of the Vancouver Art Gallery, Vancouver Art Gallery Acquisition Fund, VAG 88.11.

Indian Reserve, North Vancouver c. 1905, watercolour on paper, 19.4 × 27.1 cm, Collection of the Vancouver Art Gallery, Gift of Miss Jean McD. Russell, VAG 81.8.

Self-Portrait with Friends c. 1907, watercolour, graphite, ink on paper, 22.3 × 17.4 cm, Collection of the Vancouver Art Gallery, Vancouver Art Gallery Acquisition Fund, VAG 96.28.1.

Arbutus Tree 1907–08, watercolour, graphite on paper, 34.1 × 27.3 cm, Collection of the Vancouver Art Gallery, Vancouver Art Gallery Acquisition Fund, VAG 90.4.

Alert Bay, Mortuary Boxes 1908, watercolour, graphite on paper, 54.5 × 38.3 cm, Collection of the Vancouver Art Gallery, Emily Carr Trust, VAG 42.3.85.

Wood Interior 1909, watercolour, graphite on paper, 72.8 × 54.3 cm, Collection of the Vancouver Art Gallery, Emily Carr Trust, VAG 42.3.86.

Seated Girl 1909, watercolour, graphite on paper, 39.5 × 28.8 cm, Collection of the Vancouver Art Gallery, Anonymous Gift, VAG 99.24.1.

Dear Death, Ah Why Delay? c. 1910, watercolour, graphite on paper, 15 × 20.3 cm, Collection of the Vancouver Art Gallery, Gift of Dorothy Burnett, VAG 74.24.

Alert Bay 1910, watercolour, graphite on paper, 76.7 × 55.3 cm, Collection of the Vancouver Art Gallery, Emily Carr Trust, VAG 42.3.109.

French Landscape 1911, oil on canvas, 61.1 × 49.6 cm, Collection of the Vancouver Art Gallery, Donated by the Estate of Anna K. Jetter, VAG 2004.12.13.

Women of Brittany 1911, watercolour, graphite on paper, 44.5 × 54.6 cm, Collection of the Vancouver Art Gallery, Vancouver Art Gallery Acquisition Fund, VAG 94.63.

Return from Fishing, Guydons 1912, oil on paperboard, 96.2 × 65.2 cm, Collection of the Vancouver Art Gallery, Emily Carr Trust, VAG 42.3.51.

Skidegate 1912, oil on paperboard, 63.2 × 29.7 cm (sight), Collection of the Vancouver Art Gallery, Emily Carr Trust, VAG 42.3.72.

Yan, Q.C.I. 1912, watercolour, graphite on paper, 76.2 × 27.3 cm, Collection of the Vancouver Art Gallery, Emily Carr Trust, VAG 42.3.106.

Haida Mortuary Pole 1912, watercolour, graphite on paper, 75.8 × 27.4 cm, Collection of the Vancouver Art Gallery, Emily Carr Trust, VAG 42.3.112.

Indian Raven, Yan 1912, oil on canvas, 63.2 × 29.7 cm (sight), Collection of the Vancouver Art Gallery, Emily Carr Trust, VAG 42.3.41.

Tanoo, 1912 watercolour, graphite on paper, 76.4 × 55.5 cm, Collection of the Vancouver Art Gallery, Emily Carr Trust, VAG 42.3.94.

Skedans, 1912 watercolour, graphite on paper, 56.4 × 77.8 cm, Collection of the Vancouver Art Gallery, Emily Carr Trust, VAG 42.3.92.

Totem by the Ghost Rock 1912, oil on canvas, 90.2 × 114.7 cm, Collection of the Vancouver Art Gallery, Emily Carr Trust, VAG 42.3.10.

Kwatkiutl House 1912, oil on paperboard, 59.4 × 90.7 cm (sight), Collection of the Vancouver Art Gallery, Emily Carr Trust, VAG 42.3.33.

Tsatsisnukomi, Tribe Klawatsis 1912, watercolour, graphite on paper, 56.3 × 76.8 cm, Collection of the Vancouver Art Gallery, Emily Carr Trust, VAG 42.3.91.

Tsatsisnukomi, B.C. 1912, watercolour, graphite on paper, 55.2 × 75.6 cm, Collection of the Vancouver Art Gallery, Emily Carr Trust, VAG 42.3.88.

Indian House Interior with Totems 1912–13, oil on canvas, 89.6 × 130.6 cm, Collection of the Vancouver Art Gallery, Emily Carr Trust, VAG 42.3.8.

Skidegate 1912, oil on paperboard, 64.2 × 31.5 cm, Collection of the Vancouver Art Gallery, Emily Carr Trust, VAG 42.3.75.

Totem Poles, Kitseukla 1912, oil on canvas, 126.8 × 98.4 cm, Collection of the Vancouver Art Gallery, Founders' Fund, VAG 37.2.

Untitled (Tree on a Rocky Profile) 1922–25, oil on canvas, 40.7 × 56 cm, Vancouver Art Gallery, Vancouver Art Gallery Acquisition Fund, VAG 99.17.

Untitled (Self-Portrait) 1924, oil on paperboard, 39.4 × 44.9 cm (sight), Collection of the Vancouver Art Gallery, Emily Carr Trust, VAG 42.3.50.

Skidegate 1928, oil on canvas, 61.5 × 46.4 cm, Collection of the Vancouver Art Gallery, Emily Carr Trust, VAG 42.3.48.

The Crying Totem 1928, oil on canvas, 75.3 × 38.8 cm, Collection of the Vancouver Art Gallery, Emily Carr Trust, VAG 42.3.53.

Maud Island, Q.C.I. 1928, watercolour, graphite on paper, 76 × 56.3 cm, Collection of the Vancouver Art Gallery, Emily Carr Trust, VAG 42.3.95.

Queen Charlotte Islands Totem 1928, watercolour, graphite on paper, 75.8 × 53.3 cm, Collection of the Vancouver Art Gallery, Emily Carr Trust, VAG 42.3.97.

Totem Mother, Kitwancool 1928, oil on canvas, 109.5 × 82 cm, Collection of the Vancouver Art Gallery, Emily Carr Trust, VAG 42.3.20.

Kispiox Village 1928, watercolour, graphite on paper, 75.9 × 53 cm, Collection of the Vancouver Art Gallery, Emily Carr Trust, VAG 42.3.104.

Ankeda, The Pole of Chief George Kindealda 1928, watercolour, graphite on paper, 76.3 × 56.4 cm, Collection of the Vancouver Art Gallery, Emily Carr Trust, VAG 42.3.113.

Kitwancool 1928, watercolour, graphite on paper, 75.4 × 56.3 cm, Collection of the Vancouver Art Gallery, Emily Carr Trust, VAG 42.3.100.

Beaver Pole, Skidegate 1928–29, watercolour, graphite on paper, 75.6 × 55.9 cm, Collection of the Vancouver Art Gallery, Emily Carr Trust, VAG 42.3.96.

The Raven 1928–29, oil on canvas, 61 × 45.7 cm, Collection of the Vancouver Art Gallery, Gift of Dr. Abraham and Mrs. Naomi Greenberg, VAG 95.45.1.

Port Renfrew 1929, charcoal on paper, 64.4 × 50.7 cm, Collection of the Vancouver Art Gallery, Emily Carr Trust, VAG 42.3.120.

Agidal, Nass River c. 1929, charcoal on paper, 64 × 50.6 cm, Collection of the Vancouver Art Gallery, Emily Carr Trust, VAG 42.3.127.

Untitled 1929, charcoal on paper, 48.1 × 63 cm, Collection of the Vancouver Art Gallery, Emily Carr Trust, VAG 42.3.134.

Pines in May 1929–30, watercolour, graphite on paper, 76.8 × 53 cm, Collection of the Vancouver Art Gallery, Emily Carr Trust, VAG 42.3.103.

Old Time Coast Village 1929–30, oil on canvas, 91.3 × 128.7 cm, Collection of the Vancouver Art Gallery, Emily Carr Trust, VAG 42.3.4.

Untitled 1929–30, charcoal on paper, 62.2 × 47.5 cm, Collection of the Vancouver Art Gallery, Emily Carr Trust, VAG 42.3.125.

Untitled (formalized tree forms with totemic details) 1929–30, charcoal on paper, 62.8 × 47.7 cm, Collection of the Vancouver Art Gallery, Emily Carr Trust, VAG 42.3.123.

Untitled 1929–30, charcoal on paper, 63.1 × 47.7 cm, Collection of the Vancouver Art Gallery, Emily Carr Trust, VAG 42.3.129.

Untitled 1929–30, charcoal on paper, 44 × 32.5 cm, Collection of the Vancouver Art Gallery, Emily Carr Trust, VAG 42.3.149.

Untitled 1929–31, charcoal on paper, 91.8 × 47.7 cm, Collection of the Vancouver Art Gallery, Emily Carr Trust, VAG 42.3.114.

Port Renfrew 1929–31, charcoal on paper, 62.9 × 48.1 cm, Collection of the Vancouver Art Gallery, Emily Carr Trust, VAG 42.3.122.

Kispiox 1928, watercolour, graphite on paper, 75.4 × 56.5 cm, Collection of the Vancouver Art Gallery, Emily Carr Trust, VAG 42.3.105.

Three Totems 1929–30, oil on canvas, 109 × 69.4 cm, Collection of the Vancouver Art Gallery, Emily Carr Trust, VAG 42.3.26.

Untitled 1929–31, charcoal on paper, 30 × 45.8 cm, Collection of the Vancouver Art Gallery, Emily Carr Trust, VAG 42.3.147.

Totem Forest c. 1930, oil on canvas, 128.6 × 92 cm, Collection of the Vancouver Art Gallery, Emily Carr Trust, VAG 42.3.3.

Vanquished 1930, oil on canvas, 92 × 129 cm, Collection of the Vancouver Art Gallery, Emily Carr Trust, VAG 42.3.6.

Friendly Cove c. 1930, charcoal on paper, 76.1 × 55.8 cm, Collection of the Vancouver Art Gallery, Emily Carr Trust, VAG 42.3.117.

Untitled (Forest Interior, black, grey and white) c. 1930, oil on paper, 88.2 × 60 cm, Collection of the Vancouver Art Gallery, Emily Carr Trust, VAG 42.3.56.

Friendly Cove c. 1930, charcoal on paper, 47.7 × 62.9 cm, Collection of the Vancouver Art Gallery, Emily Carr Trust, VAG 42.3.130.

Zunoqua 1930, watercolour, graphite on paper, 44.3 × 31.8 cm, Collection of the Vancouver Art Gallery, Emily Carr Trust, VAG 42.3.101.

Untitled (landscape with "eye" in sky) 1930, charcoal on paper, 48.1 × 62.9 cm, Collection of the Vancouver Art Gallery, Emily Carr Trust, VAG 42.3.136.

Deserted Village 1930-31, charcoal on paper, 64.8 × 49.4 cm, Collection of the Vancouver Art Gallery, Emily Carr Trust, VAG 42.3.126.

Silhouette No. 2 1930-31, oil on canvas, 130.2 × 86.5 cm, Collection of the Vancouver Art Gallery, Emily Carr Trust, VAG 42.3.7.

Untitled (Tree) 1930-31, charcoal on paper, 30 × 45.8 cm, Collection of the Vancouver Art Gallery, Emily Carr Trust, VAG 42.3.141.

Deep Forest c. 1931, oil on canvas, 69.3 × 111.8 cm, Collection of the Vancouver Art Gallery, Emily Carr Trust, VAG 42.3.16.

Sea Drift at the Edge of the Forest c. 1931, 112.4 × 68.9 cm, oil on canvas, Collection of the Vancouver Art Gallery, Emily Carr Trust, VAG 42.3.25.

Strangled by Growth 1931, oil on canvas, 64 × 48.6 cm, Collection of the Vancouver Art Gallery, Emily Carr Trust, VAG 42.3.42.

The Little Pine 1931, oil on canvas, 112 × 68.8 cm, Collection of the Vancouver Art Gallery, Emily Carr Trust, VAG 42.3.14.

Totem and Forest 1931, oil on canvas, 129.3 × 56.2 cm, Collection of the Vancouver Art Gallery, Emily Carr Trust, VAG 42.3.1.

Tree Trunk 1931, oil on canvas, 129.1 × 56.3 cm, Collection of the Vancouver Art Gallery, Emily Carr Trust, VAG 42.3.2.

Tree Study c. 1930, oil on paper, 45.5 × 29.7 cm, Collection of the Vancouver Art Gallery, Vancouver Art Gallery Acquisition Fund, VAG 91.3.

Forest 1931-33, oil on canvas, 118.2 × 76.1 cm, Collection of the Vancouver Art Gallery, Emily Carr Trust, VAG 42.3.13.

A Young Tree 1931, oil on canvas, 112 × 68.5 cm, Collection of the Vancouver Art Gallery, Emily Carr Trust, VAG 42.3.18.

Big Raven 1931, oil on canvas, 87 × 114 cm, Collection of the Vancouver Art Gallery, Emily Carr Trust, VAG 42.3.11.

Koskimo 1930, charcoal on paper, 78.5 × 57.7 cm, Collection of the Vancouver Art Gallery, Emily Carr Trust, VAG 42.3.119.

Zunoqua of the Cat Village 1931, oil on canvas, 112.2 × 70.1 cm, Collection of the Vancouver Art Gallery, Emily Carr Trust, VAG 42.3.21.

Untitled (Tree) 1931-32, charcoal on paper, 91.2 × 61 cm, Collection of the Vancouver Art Gallery, Emily Carr Trust, VAG 42.3.115.

Red Cedar 1931, oil on canvas, 111 × 68.5 cm, Collection of the Vancouver Art Gallery, Gift of Mrs. J.P. Fell, VAG 54.7.

Old and New Forest 1931–32, oil on canvas, 112.2 × 69.8 cm, Collection of the Vancouver Art Gallery, Emily Carr Trust, VAG 42.3.23.

Forest, British Columbia 1931–32, oil on canvas, 130 × 86.8 cm, Collection of the Vancouver Art Gallery, Emily Carr Trust, VAG 42.3.9.

Abstract Tree Forms 1931–32, oil on paper, 61.1 × 91.1 cm, Collection of the Vancouver Art Gallery, Emily Carr Trust, VAG 42.3.54.

Untitled 1931–32, oil on paper, 46 × 30 cm, Collection of the Vancouver Art Gallery, Emily Carr Trust, VAG 42.3.167.

Untitled 1931–32, oil, charcoal on paper, 46 × 30 cm, Collection of the Vancouver Art Gallery, Emily Carr Trust, VAG 42.3.160.

Untitled (spiralling upward) 1932–33, oil on paper, 87.5 × 58 cm, Collection of the Vancouver Art Gallery, Emily Carr Trust, VAG 42.3.63.

Wood Interior 1932–35, oil on canvas, 130 × 86.3 cm, Collection of the Vancouver Art Gallery, Emily Carr Trust, VAG 42.3.5.

Untitled 1932–33, oil on paper, 59.8 × 91.1 cm (sight), Collection of the Vancouver Art Gallery, Emily Carr Trust, VAG 42.3.58.

Village below the Mountain 1933, oil on paper, 56.6 × 86.7 cm, Collection of the Vancouver Art Gallery, Vancouver Art Gallery Acquisition Fund, VAG 89.24.

Formalized Trees, Spring c. 1933, oil on paper, 90 × 59.5 cm, Collection of the Vancouver Art Gallery, Emily Carr Trust, VAG 42.3.55.

Pemberton Meadows 1933, oil on canvas, 91.3 × 68.7 cm, Collection of the Vancouver Art Gallery, Emily Carr Trust, VAG 42.3.36.

Village in the Hills 1933, oil on canvas, 69 × 112.2 cm, Collection of the Vancouver Art Gallery, Emily Carr Trust, VAG 42.3.22.

Untitled 1933–34, oil on paper, 91 × 57.8 cm (sight), Collection of the Vancouver Art Gallery, Emily Carr Trust, VAG 42.3.79.

Forest Edge and Sky c. 1934, oil on paper, 91.2 × 61.4 cm, Collection of the Vancouver Art Gallery, Emily Carr Trust, VAG 42.3.65.

Stumps and Sky c. 1934, oil on paper, 59.5 × 90 cm, Collection of the Vancouver Art Gallery, Emily Carr Trust, VAG 42.3.66.

Loggers' Culls 1935, oil on canvas, 69 × 112.2 cm, Collection of the Vancouver Art Gallery, Gift of Miss I. Parkyn, VAG 39.1.

A Rushing Sea of Undergrowth 1935, oil on canvas, 112.8 × 68.9 cm, Collection of the Vancouver Art Gallery, Emily Carr Trust, VAG 42.3.17.

Young Pines and Sky c. 1935, oil on paper, 88.8 × 58.2 cm, Collection of the Vancouver Art Gallery, Emily Carr Trust, VAG 42.3.80.

Mountain Forest 1935–36, oil on canvas, 112 × 69 cm, Collection of the Vancouver Art Gallery, Emily Carr Trust, VAG 42.3.27.

Scorned as Timber, Beloved of the Sky 1935, oil on canvas, 112 × 68.9 cm, Collection of the Vancouver Art Gallery, Emily Carr Trust, VAG 42.3.15.

Overhead 1935–36, oil on paper, 61 × 91 cm, Collection of the Vancouver Art Gallery, Emily Carr Trust, VAG 42.3.69.

Untitled (Forest) c. 1936, oil on paper, 60.5 × 92 cm, Collection of the Vancouver Art Gallery, Gift of Mrs. Elma M. DesBrisay, VAG 87.17.

Victoria Sight across the Water c. 1937, oil on paper, 55 × 84.3 cm, Collection of the Vancouver Art Gallery, Gift of J. Ron Longstaffe, VAG 85.73.

The Coast of Juan de Fuca c. 1936, oil on paper, 61 × 90.5 cm, Collection of the Vancouver Art Gallery, Gift of Dorothy-Jane and Harry Boyce, VAG 2008.40.1.

Masset Bears c. 1941, oil on canvas, 101.4 × 44.9 cm, Collection of the Vancouver Art Gallery, Emily Carr Trust, VAG 42.3.45.

Untitled (Rhythm of Nature) c. 1937, oil on canvas, 48.5 × 59.6 cm, Collection of the Vancouver Art Gallery, Gift of Dr. Abraham and Mrs. Naomi Greenberg, VAG 95.45.2.

Nass River Pole, B.C. 1928, watercolour, graphite on paper, 56.3 × 74.4 cm, Collection of the Vancouver Art Gallery, Vancouver Art Gallery Acquisition Fund with the assistance of the Government of Canada through the Cultural Property Export and Import Act, VAG 91.28.

Forsaken 1937, oil on canvas, 119.1 × 76.5 cm, Collection of the Vancouver Art Gallery, Emily Carr Trust, VAG 42.3.12.

Above the Gravel Pit 1937, oil on canvas, 77.2 × 102.3 cm, Collection of the Vancouver Art Gallery, Emily Carr Trust, VAG 42.3.30.

Young Pines and Old Maple 1937–38, oil on paper, 59.8 × 89.7 cm, Collection of the Vancouver Art Gallery, Emily Carr Trust, VAG 42.3.76.

Mrs. Jones' Farm c. 1938, oil on paper, 61.3 × 91 cm (sight), Collection of the Vancouver Art Gallery, Emily Carr Trust, VAG 42.3.81.

Deep Woods 1938–39, oil on paper, 61.4 × 91.5 cm (sight), Collection of the Vancouver Art Gallery, Emily Carr Trust, VAG 42.3.67.

Untitled 1938–39, oil on paper, 90.8 × 60.8 cm, Collection of the Vancouver Art Gallery, Emily Carr Trust, VAG 42.3.84.

Above the Trees c. 1939, oil on paper, 91.2 × 61 cm, Collection of the Vancouver Art Gallery, Emily Carr Trust, VAG 42.3.83.

Skidegate (Shark Pole) 1912, oil on paperboard, 64.6 × 31.2 cm (sight), Collection of the Vancouver Art Gallery, Emily Carr Trust, VAG 42.3.73.

A Skidegate Pole 1941–42, oil on canvas, 87 × 76.5 cm, Collection of the Vancouver Art Gallery, Emily Carr Trust, VAG 42.3.37.

Skidegate 1912, oil on paperboard, 64.7 × 32.6 cm, Collection of the Vancouver Art Gallery, Emily Carr Trust, VAG 42.3.47.

A Skidegate Beaver Pole 1941–42, oil on canvas, 86 × 76.3 cm, Collection of the Vancouver Art Gallery, Emily Carr Trust, VAG 42.3.38.

Cedar Sanctuary 1942, oil on paper, 91.5 × 61 cm, Collection of the Vancouver Art Gallery, Emily Carr Trust, VAG 42.3.71.

Cedar 1942, oil on canvas, 112 × 69 cm, Collection of the Vancouver Art Gallery, Emily Carr Trust, VAG 42.3.28.

24 25 26 27 28 — 11 10 9 8 7

Douglas and McIntyre (2013) Ltd.
P.O. Box 219, Madeira Park, BC, VON 2H0
www.douglas-mcintyre.com

Vancouver Art Gallery,
750 Hornby Street, Vancouver, BC, V6Z 2H7
www.vanartgallery.bc.ca

Cataloguing data available from Library and Archives Canada
ISBN 978-1-77100-080-2 (pbk.)

Editing by Lucy Kenward
Copyediting by Shirarose Wilensky
Cover illustration: *Above the Gravel Pit*, 1937, oil on canvas, 77.2 x 102.3 cm,
Collection of the Vancouver Art Gallery, Emily Carr Trust, VAG 42.3.30
Frontispiece: *A Skidegate Pole*, 1941–42, oil on canvas, 87 x 76.5 cm, Collection of
the Vancouver Art Gallery, Emily Carr Trust, VAG 42.3.37
Back cover photograph: *Emily Carr in Her Studio* by Harold Mortimer Lamb, 1939

Printed and bound in South Korea

We gratefully acknowledge the financial support of the Canada Council for the
Arts, the British Columbia Arts Council, the Province of British Columbia
through the Book Publishing Tax Credit and the Government of Canada
through the Canada Book Fund for our publishing activities.